The Power of the Unexpected

PROVOCATIVE GRAPHICS

in Graphic Design

ROCKPORT

PROVOCATIVE
GRAPHICS

The Power of the Unexpected in Graphic Design

Laurel Harper

GLOUCESTER MASSACHUSETTS

ROCKPORT PUBLISHERS

First published in the United States of America by
Rockport Publishers, Inc.
33 Commercial Street
Gloucester, Massachusetts 01930-5089
Telephone: (978) 282-9590
Facsimile: (978) 283-2742
www.rockpub.com

ISBN 1-56496-725-5

10 9 8 7 6 5 4 3 2 1

Design: M A T T E R
Cover Design: M A T T E R
Cover Image: Kim Cook

Printed in China.

For everyone who is tired of being told what you can and can't do.

TABLE

OF C

CONTENTS

READ THIS, ASS.

foreword
by stefan sagmeister

Did this insult provoke you into reading on? If you're still with me now, I guess it did. Cheap trick? Absolutely. A prime example of a provocation for the sake of it. Okay, now that I have your attention, where do I go from here? I could argue that the words "provocative graphics" are a tautology, because all graphics inherently have to provoke just to qualify as such. If a piece of graphic design does not provoke, if it does not get your attention, if it does not shake you out of what you're doing, well, then it's merely a picture. There are many possibilities: besides infuriating the audience with the old sex and violence staples, we can provoke with form (think Malevitchs' painting of a black square), color (think a Mets cap worn to a Yankees game), and of course language (wars were ignited, countries united, and history changed by a couple of provocative printed words). **And:** When deliberate provocation becomes the norm,

HOLE!

provocation provokes nobody. Since every soft drink and credit card commercial has to be "cool," designs for the youth market have to be "provocative" (or, worse, "edgy") to be approved by the client, resulting in a great sea of bland overall sameness. Clichés such as raised middle fingers, snarling mouths, punk haircuts, tattooed faces, strange piercings, distressed type, images of medical procedures, cross-processed photography (and any combination of the aforementioned) are everywhere, busy canceling each other out. **English being my second language, I had to look up "provocative" in Webster's dictionary. Here's what it said: "1. to excite. 2. to arouse annoyance deliberately."** Hope to do more of the former, less of the latter.

THE POWER OF PROVOCATION

/ pro VAK'e tiv, pre- / adj.
Provoking or tending to provoke,
as to action, thought, feeling, etc.;
stimulating, erotic, irritating, etc.

Pablo Picasso. Max Ernst. Paul Klee. Wassily Kandinsky. Undoubtedly some of the greatest artists to come out of the twentieth century. Yet in 1937, their work was lumped together in an exhibition designed by the Nazis solely for the purpose of humiliating them and their colleagues. The Entartete Kunst ("degenerate art") campaign resulted in the confiscation of more than 20,000 pieces of art created by more than 200 people whom the Third Reich deemed "demented." The criteria for what qualified for the exhibition was simple. Anything applied that didn't fit Adolf Hitler's notion of art, which was that it had to be "eternal" and "perfect," and it had to glorify the Aryan way of life. "True art is and remains eternal; it does not follow the law of the season's fashions," Hitler said. The Degenerate Artists suffered such fierce persecution because of their inventive styles. Their work was not intended to merely replicate a glorious scene, as Hitler desired, or, in the case of designers, to provide decoration only. Instead, they wanted to stimulate their audiences, moving them to take action or to react emotionally. Most of those in the group followed the lead of the expressionists, who distorted reality to express an inner vision, or the surrealists, whose art expressed their imaginations without reason and constraint. The Degenerates' work also was content-driven. Consequently, it often clashed with the Third Reich mindset, as well as that of most Germans who were still recovering from the pummeling their pride took during World War I. Yet that did not stop the Degenerates from voicing their opinion. On viewing the 1934 poster "O Tannenbaum," for instance, who can doubt the repugnance that John Heartfield, a member of the Berlin Dadaists, felt for the Nazis? Heartfield took an icon normally associated with happiness and comfort—a Christmas tree—and gave it an ominous twist by forming it out of sickly, mangled branches bent in the shape of tiny swastikas. The work of Heartfield and other innovators from the early decades of the 1900s still influences creatives today, and will surely do so for generations to come. Yet the skill with which they expressed themselves proved to be a double-edged sword. While the artists' sentiments were clearly stamped on the public mind, their talent also made them a prime target of the Third Reich. The authorities went after them with a vengeance, seeking to disgrace and, in some cases, literally destroy them. Not only were they subjected to ridicule in such ways as the Degenerate Art exhibition, but before Hitler's grim reign was over hundreds of Europe's greatest talents had been arrested, driven into exile, or even murdered.

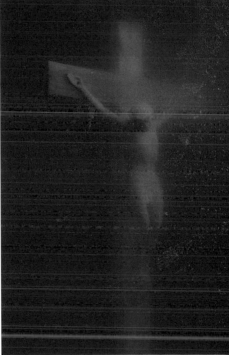

ANDRES SERRANO, "PISS CHRIST," 1987, COURTESY PAULA COOPER GALLERY, NEW YORK

Harnessing the Power

The Nazi purging offers one of the most extreme examples in contemporary times of the extent to which art can incite an audience. However, the plight of the Degenerate Artists is by no means an isolated incident. Throughout history, art has served to insult, inspire, inflame, uplift, arouse, seduce—in short, provoke—audiences in all sorts of ways. Think about the Christian cross, the Star of David, or the Klansman's hood. Each is an icon that evokes a strong emotional response, a reaction that is likely to be as intense today as when the symbol first made its appearance hundreds or even thousands of years ago. But whether the emotion the viewer feels is joy or reverence, hate or fear, depends on that person's own particular bias. As the years have passed and the impact an image can make on viewers has grown more evident, artists and designers have learned to play off the public's many passions and prejudices. They have learned to harness the power of graphics to garner attention for clients, causes, and even themselves. As an example of how graphics can sway opinion,

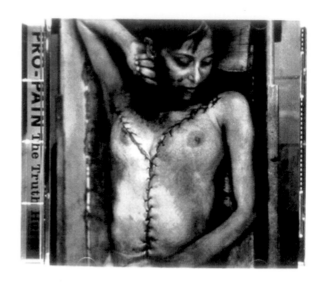

consider those working in the political arena. They are sophisticated masters at using graphic stimulation and insinuation to place their candidates in power. In fact, the first American national advertising campaign sprang from an early presidential race. When a Republican newspaper sought to put down Whig candidate William Henry Harrison during the 1840 election by saying, "Give him a barrel of hard cider and a pension of $2,000 a year and...he will sit the remainder of his days in a log cabin...," Harrison's savvy campaigners quickly retaliated by depicting Harrison as a humble, log cabin-dwelling hero of the American people, and produced numerous campaign items embellished with little log cabins and hard cider barrels to promulgate the image. In truth, Harrison was a rich man who lived in a stately home situated on 2,000 acres in Ohio. But Americans bought into their champion's newly created "humility" and Harrison defeated Republican incumbent Martin Van Buren to become ninth president of the United States. Many artists and designers have used provocation to further their own personal careers, having discovered that the more indignant the reaction to their work, the more memorable they were likely to become. Chris Ofili, Andres Serrano, and Robert Mapplethorpe offer prime examples of how provoking the wrath of the public can etch your name in its mind. Mapplethorpe's enchantingly beautiful, but wholly erotic (and some believe pornographic) flower and sado-masochistic photographs of nude males angered authorities so much that one museum director was put on criminal trial for showing them. Dennis Barrie, head of the Contemporary Arts Center in Cincinnati, Ohio, was brought up on charges of public indecency when he refused to censor out a select group of photographs from a Mapplethorpe exhibit that the local authorities had declared obscene. Not long after, Serrano's "Piss Christ" series of photos (which inspired the tongue-in-cheek cover of this book) sparked a similar reaction. Serrano uses photography to convey his belief that the world is filled with contradiction; "Piss Christ" does this by showing a crucifix in a jar of urine. Unlike Barrie, who stood firm throughout his ordeal, the director of the National Gallery of Victoria in Canada closed down Serrano's show, catapulting to public outrage over the exhibit and those photos in particular. The Brooklyn Museum of Art suffered a comparable fate. Its funding was pulled because of an exhibit that featured work such as a painting by British artist Chris Ofili of elephant feces glued to the Virgin Mary's breast.

Fickle Responses

Though the power of graphics to provoke an audience is undeniable, it is often hard to predict just what reaction an image will generate. Audiences are affected to different degrees and in different ways. Some might consider the same image, for instance, to be beautiful, grotesque, pitiful, or morbid. A now infamous CD cover designed by Stefan Sagmeister effectively demonstrates the spectrum of responses that a single image can evoke. Sagmeister used a full-bleed, black-and-white photograph on the cover, then ran the band's name and CD title discreetly along the jewel box's edge. This sparse design treatment was all that was needed to create a memorable, haunting impression, as the photo carried the work into infamy. It showed an unidentified woman's body in the morgue following her autopsy. A ghastly, crudely stitched incision runs from her abdomen to her breasts, then angles sharply upward to each shoulder. Yet despite the appalling mutilation of her body, the woman retains a sense of dignity, bearing a serene expression even in death. Viewer reaction ran the gamut from those who were disgusted and horrified to those who told Sagmeister that the image was "cool." On reflection, Sagmeister says he regrets his choice of image. He still believes the photograph could be beneficial when employed for the right cause, but with hindsight he has come to the conclusion that a hard rock band's CD cover was not the proper place for such a somber photograph. Provocative art and artists have long been stirring up heated arguments worldwide, mainly centered around just what constitutes art. Should governments finance work that enrages the general population is also part of that debate. Passion probably runs no stronger than within the creative community itself, where members of opposing views are vehemently outspoken and quick to turn on one another. Despite the controversy, the enthusiasm for experimentation hasn't diminished. In the design community, at least some of that thirst for innovation was spurred by the introduction of an array of technological tools in the 1990s, a parade that continues today. Users seem bent on discovering just how far their new play toys will allow them to go. Though as time passes some of the dazzle of the technology is fading, it has served to inspire a whole new era of provocative design, leaving those who embrace technology and those who don't waging an inspired crusade to push the boundaries and incite their audiences in all sorts of ways. Still, the main catalyst that drives creatives to provocation is not technology, but the need for personal fulfillment. Rick Valicenti, who emerged as one of the most controversial designers of the 1990s, mostly for being among the first to inject his personal art into client assignments, explains this need best. His own transformation from mere designer to a connoisseur of provocation came when he reached the point in his career where he had to learn to invest in himself, rather than to always serve those who came knocking at his studio door. The client, he explained, had the option to go knock on someone else's door, while he always had to live with himself. Valicenti is joined by hundreds of like-minded colleagues across the world, from Art Chantry and Plazm Media working in the U.S.'s Northwestern regions to the radical Guerrilla Girls in New York City, Wild Plakken in Europe, and Najime Tachibana in Japan. Whether their message is "hear me," "help me," or even the more pedestrian "buy me," they skillfully employ a mix of sex, satire, black humor, and other inflammatory material that turns design into an emotionally charged, powerful weapon. They and their many exciting colleagues would undoubtedly be on the Degenerate hit list if the Nazis were still in power today. But rather than to serve to humiliate and denigrate, as the Third Reich intended, being numbered among the nontraditional, provocative artist regime has become a mark of achievement that can be borne with pride.

author's note

With the broad assortment of connotations attached to the word "provocative," determining just what qualified for inclusion in this book was a massive task in itself. In the end, I turned to the thesaurus, narrowing down the dozens of synonyms for "provocative" to those used to designate the chapters found here. These particular words were chosen because each offered a slightly different nuance of "provocative" and collectively they represent its spectrum of meanings. A call then went out worldwide to design studios that produce a bulk of provocative work. While this is by no means the definitive reference of provocative artists—there are, undoubtedly, many others famous and not so famous who could rightfully have been included here—it does offer a good overview of the provocative work being produced today. Hopefully, it will serve to guide others along the path to creating their own emotionally packed work that induces the desired and proper response.

OUTRAGEO

chapter 1

/('')aut-'rajes/ **a:** exceeding the limits of what is normal or tolerable **b:** not conventional or matter-of-fact **c:** unrestrained

What makes some designers so good at upsetting the status quo? What makes their work wonderfully outrageous? Is it a proclivity for defiance? A warped thought process that manages to turn even the most pedestrian assignment into a profane outing? Courage to endure the criticism that inevitably stalks those who defy convention? **Or is the person simply a bit wacked?** The truth is, it's a little of all of these. But then it goes one step further: To be truly effective, an "outrageous" design must, paradoxically, make sense. Idea and execution must merge into a seamless message that packs both a visual and a conceptual wallop. There's no limit to the number of ways that this can be accomplished. The work can illustrate a bold idea in a simple manner. For example, look at how Modern Dog Design Co.'s ad for Warner Bros. commemorates *HIT* magazine's eighth anniversary. It puts some of the client's most notable icons to work in a totally unexpected way, with Bugs Bunny's white-gloved, gray "paw" poking through the center of Warner's trademark vortex—and flipping the publication off. Why did Warner allow the designers to get away with this? Because it matched both *HIT*'s attitude and its reputation. Even more so, it was in keeping with the cartoon character's humorously sarcastic mien, as Bugs Bunny fans everywhere can attest. Outrageous can also succeed through the bold execution of a simple idea. When Stefan Sagmeister was asked to create a call-for-entries poster for the 4A's advertising awards in Hong Kong, for instance, he called on the obvious to garner attention— four men baring their bottoms (PAGE 32). The idea would likely come to the minds of many upon hearing the term "4A's." But while most other designers would only have joked about doing something so corny and potentially offensive, the young Austrian unabashedly carried the concept to its fully fleshed-out conclusion, even hiring traditional Chinese artists to paint a detailed image. In the process, Sagmeister incensed an entire global region—including garnering front-page attention in the South China Morning Post, the area's largest daily newspaper. Although he has since created many equally outlandish and memorable works, this poster has become the signature piece for which Sagmeister is noted worldwide. An unusual or unexpected technical application also can turn the mundane into the memorable. Weirdly proportioned people, for example, give a different twist to photos that illustrate a series of direct-mail cards advertising a company's Web site services (PAGE 17). **More advanced computer technology enables an infant to sing about his "big bad dad's" driving prowess in a commercial for a sports utility vehicle. Unlike many crudely dubbed foreign movies where dialogue and lip movement never match up, in even the tightest camera shots the child's mouth perfectly forms every word. These examples and others like them succeed because of their creators' attention to detail and flawless execution, and because they are sensitive to when an outrageous approach is or isn't appropriate. And that, too, is a trait of a skillfully outrageous design. It might rely on the extreme for its concept, but when it comes to the thought process that goes into its development and how it is accomplished, the creator takes as many pains to get it right as if it were the most serious, high-paying project.**

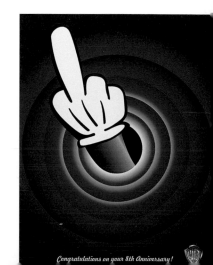

Congratulations on your 8th Anniversary!

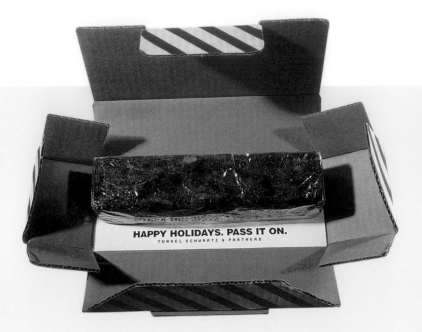

DESIGN COMPANY
Turkel Schwartz & Partners

Recognizing the destiny of most fruitcakes, this ad agency's holiday promotion invites recipients to "pass it on."

DESIGN COMPANY
Why Not Associates

Young artists who sizzle the senses are aptly portrayed in this poster that Why Not Associates created to announce a showing at London's Royal Academy of Arts.

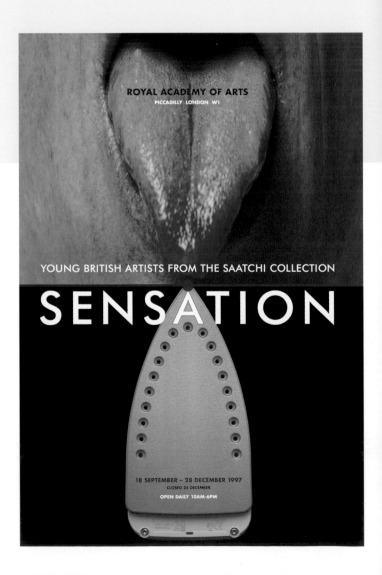

ROYAL ACADEMY OF ARTS
PICCADILLY LONDON W1

YOUNG BRITISH ARTISTS FROM THE SAATCHI COLLECTION

SENSATION

18 SEPTEMBER – 28 DECEMBER 1997
CLOSED 25 DECEMBER
OPEN DAILY 10AM-6PM

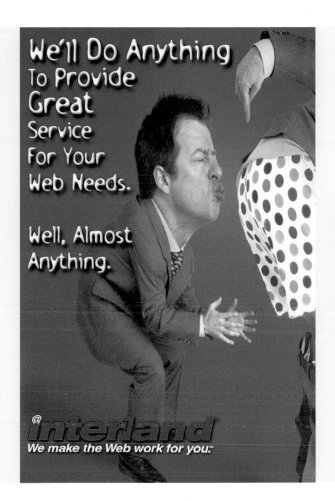

We'll Do Anything To Provide **Great** Service For Your Web Needs.

Well, Almost Anything.

@**interland**
We make the Web work for you.™

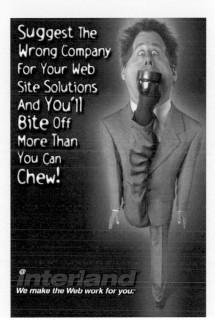

Suggest The Wrong Company For Your Web Site Solutions And You'll **Bite** Off More Than You Can **Chew!**

@**interland**
We make the Web work for you.™

DESIGN COMPANY
Marketing Associates USA

Marketing Associates USA created this series of direct mail cards to announce Interland Inc.'s Web services. The ads pair "typical" business promises, aptly conveyed by Graham French's wacky computer illustrations (available as stock images through Masterfile), with humorous text to leave a lasting impression. Michael Petty was senior art director on the project.

Provocativels As Provocative Does: an email debate

"Provocation" can mean many different things, depending on one's own experiences, openness, culture, upbringing, familiarity with the so-called source of provocation (after all, the provocative effect diminishes with use), et cetera, et cetera. So what exactly does constitute "provocative," then, and is it truly a legitimate and effective design tool? >>>

DESIGNER
Max Kisman

Max Kisman's iconography gives new meaning to the term "email." Kisman often takes an uncompli- cated approach to his work, following the belief that most icons should be as clear and simple as possible to communicate well.

DESIGN COMPANY
Planet Propaganda

Planet Propaganda easily switches between wordplay and playful icons as the basis for its ads. Shown here are campaigns developed for a hair salon and a gourmet sandwich shop.

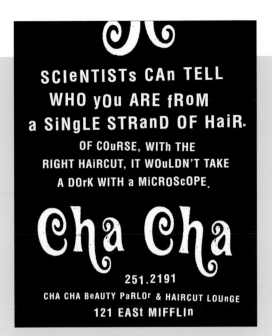

SCIENTISTs CAn TELL WHO yOu ARE fROM a SiNgLE STRanD OF HaiR. OF COuRSE, WITH THE RIGHT HAIRCUT, IT WOuLDN'T TAKE A DOrK WITH a MiCROScOPE.

Cha Cha

251.2191

CHA CHA BeAUTY PaRLOr & HAIRCUT LOUnGE
121 EASt MIFFLIn

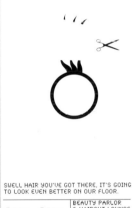

SWELL HAIR YOU'VE GOT THERE, IT'S GOING TO LOOK EVEN BETTER ON OUR FLOOR.

CHA CHA | BEAUTY PARLOR & HAIRCUT LOUNGE 121 EAST MIFFLIN TEL: 251.2191

YOU'LL FALL IN LOVE WITH YOURSELF ALL OVER AGAIN.

Cha Cha | BEAUTY PARLOR & HAIRCUT LOUNGE 121 EAST MIFFLIN TEL: 251.2191

SPOnTANEOuS COMBUSTIOn.
ALIeN ABdUCTIOn.
A SuMMeR JOb.

(HEY, YOu NEVER KNOW.
TRy To LOOk NICe.)

Cha Cha

251.2191
CHA CHA BeAUTY PaRLOr & HAIRCUT LOUnGE
121 EASt MIFFLIn
WE CARRY TIGI HAIRCARE PRODUCTS.

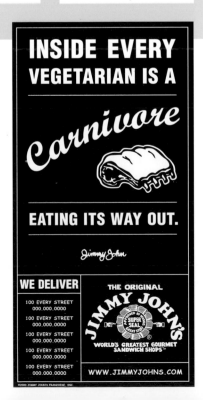

INSIDE EVERY VEGETARIAN IS A

Carnivore

EATING ITS WAY OUT.

Jimmy John

WE DELIVER

100 EVERY STREET
000.000.0000

100 EVERY STREET
000.000.0000

100 EVERY STREET
000.000.0000

100 EVERY STREET
000.000.0000

100 EVERY STREET
000.000.0000

THE ORIGINAL
JIMMY JOHN'S
SUPER SEAL
WORLD'S GREATEST GOURMET SANDWICH SHOPS™

WWW.JIMMYJOHNS.COM

©2000 JIMMY JOHNS FRANCHISE, INC.

<<< Q: Just what is "PROVOCATIVE"?

Ha_ey Johnson: Something that instantly grabs the senses and/or memory.

It causes people to feel, think, and create dialogue about something

they might otherwise pass by. >>>

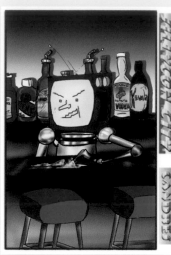

DESIGNER

Charles Andres

Cartoonist Charles Andres gives a
new twist to some previously
"happy" ad icons in his Web strip
"Sillycon City" (www.E-PIX.com). The
characters have taken on a wizened,
sarcastic edge as the unemployed
has-beens who now spend their time
hanging out in a bar lamenting about
the good old days. Andres uses the
site to promote his talents.

DESIGNER

Max Kisman

Cartoon text bubbles in this illustra-
tion by Max Kisman cleverly convey
the depth of conversation that occurs
between couples engaged in sex.

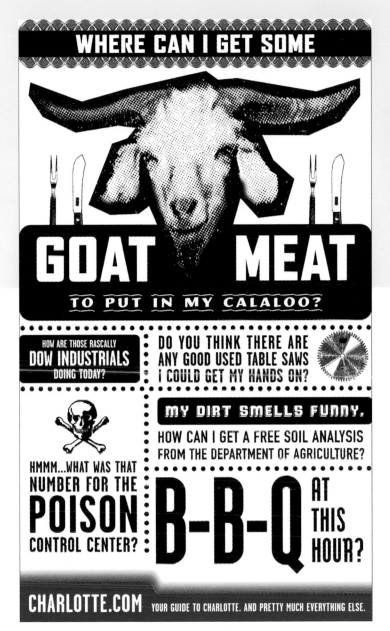

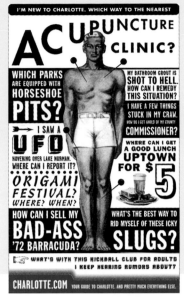

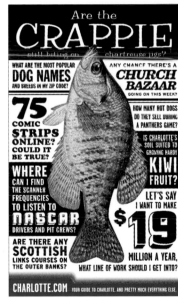

DESIGN COMPANY
Planet Propaganda

This campaign is for the Charlotte Observer newspaper's Web site. As the site has everything in it that one might want to know about Charlotte, North Carolina, the design studio sought out the more interesting aspects and then presented them in an attention-grabbing manner.

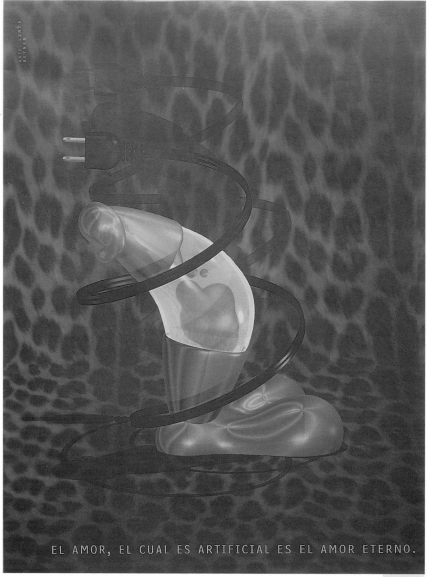

EL AMOR, EL CUAL ES ARTIFICIAL ES EL AMOR ETERNO.

DESIGN COMPANY
Plazm

A lava lamp from the 1970s along with that era's free-love attitude are conveyed via this illustration, "Penis Lava Lamp," created as a humorous visual commentary for *Plazm* magazine.

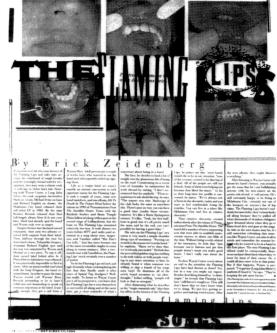

DESIGN COMPANY
Stewart A. Williams Design

The rise of the Flaming Lips rock group is the subject of a feature story in "The Rocket." Art director Stewart Williams used the group's name as inspiration for his own interpretation of the article.

DESIGNER
Rafal Olbinski

Rafal Olbinski often brings an unex-
pected touch of humor to the
highbrow world of opera and ballet via
his surrealistic poster illustrations.

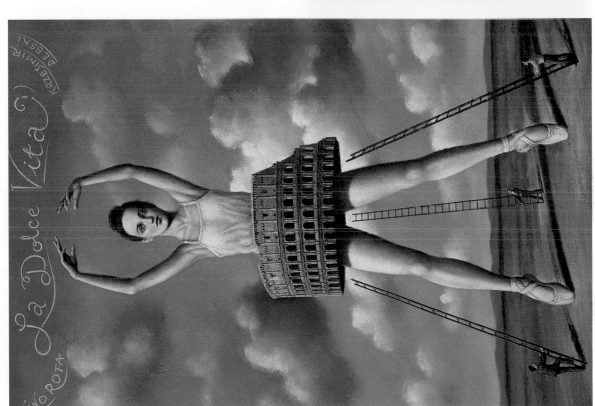

<<< Citrus (cont.): In a purist form, most would accept the word to have an alliance to
"provoke"—to provoke a reaction to or from something. In this form, anything that makes us
act upon, or really think about a subject rather than disregard it, is provocative. >>>

DESIGN COMPANYS
Plazm and Studio J

John Jay of Studio J and the designers
at Plazm teamed up to create this
advertising campaign for the Portland
Institute for Contemporary Art. The
color itself elicits political, sexual, and
gender overtones, while the various
body parts are icons for the senses.
The elegant posters were posted
graffiti-style along city sidewalks and
on utility poles.

counter
canvas
A Visual Exhibition
October 4th through November 26th

PICA

720 SW Washington, Suite 700
Portland, OR 97205
503.242.1419
www.pica.org

<<< Citrus (cont.): The oldest, simplest, and most direct forms of provocative art are delivered through the spoken or written word. Literary pieces and poetry are perhaps the most emotion-stimulating art mediums for achieving this reaction, as they stimulate the imagination (unconscious/dream mind) more directly than the eye (conscious/factual mind). >>>

DESIGN COMPANY
Planet Propaganda

Designers Kevin Wade (left) and Michael Byzewski (right) created these posters (part of a series done by various Planet designers) to announce a series of local shows.

Peepod™

DESIGN COMPANY
Segura Inc.

What Carlos Segura was doing when he got his inspiration for this new font of dingbats is best left to the imagination.

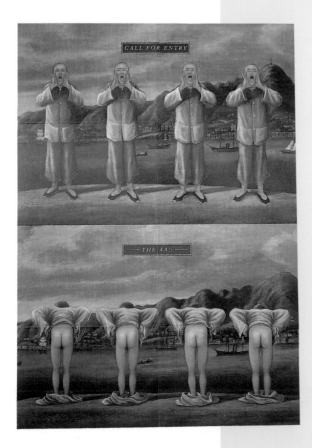

DESIGN COMPANY
Sagmeister Inc.

Stefan Sagmeister doesn't mind occasionally poking a bit of fun at clients, as this call-for-entries poster for the Southeast Asia Association of Accredited Advertising Agencies—better known as the 4A's— proves. Yet he does it with such skill and humor that clients rarely mind.

"Don't touch yourself there. That's naughty!" "It's all perfectly natural." "Keep doing that and you'll go blind!" To most people, the word "provocative" means sex. And in the minds of many marketers, **sex equals sales**. But with all the contradictory views toward sex that exist worldwide, it's often hard to determine just when it's appropriate to use sex to sell and when it isn't. Japan's artists, for instance, have for centuries produced the erotically explicit netsuke statuettes. Yet even in these so-called progressive days of the twenty-first century, sex is not a subject most Japanese parents or schools want to address. That attitude sends out a myriad of conflicting messages. One Japanese woman confesses that she and her contemporaries grew up clueless about sex. In fact, she was nearly twenty years old before she learned how to kiss—by reading a how-to article in a teen magazine. Even in the United States one encounters a broad spectrum of feelings toward the subject. One print advertisement in particular offers a prime example of the gamut of responses the same sexual image can generate. The ad, for a line of men's shoes, featured a young woman stretched at her man's feet, provocatively stroking his footgear. However, she wasn't the source of controversy. It was the tight pants her well-endowed beau wore and how they revealed his obvious affection for her. On both coasts of the United States, the ad hardly raised an eyebrow. But, in between, reaction ranged from mild debate over its appropriateness to total outrage. One regional magazine publisher in the South, the heart of the conservative Bible belt, was so incensed when he discovered the ad in his magazine just before it was sent to subscribers that he stopped the mailing. His staff received a stern reprimand, the ad was ejected, and the entire issue reprinted. Though it cost him U.S. $70,000 in printing charges alone—not to mention he chanced alienating a major advertiser—the publisher felt the expense was worth it. He had a reputation to uphold and his neighbors just weren't ready for such trash, he reasoned. His reaction might seem extreme, but it's likely that he made a wise decision. He knew his market and its tolerance level. The ad had been created by a studio in an area where sexual mores were obviously much less stringent. What some consider seductive, others view as pornographic. Despite the diverse reactions to sex that one encounters, some designers have a knack for infusing their work with eroticism in a manner that gains almost universal acceptance. John Jay of Wieden Kennedy Tokyo is among the best. His work is surreptitiously sexual, a quality he achieves through a masterful manipulation of voluptuous typography paired with sensually lit images of subjects who in and of themselves probably wouldn't arouse any lustful passion (page 36). Jay's delicate sense of composition and use of earthy colors, subtle spot varnishes, and tints also lend his work a gently seductive intrigue. On the other hand, there is Max Kisman of San Francisco, a transplanted Dutchman whose creations occasionally border on the obscene. Yet he, too, manages to attract fans from all over the world because even his most explicit sexual pieces approach the subject with humor. "If 6 Was 9" [page 37], an illustration Kisman created for a Japanese publication on digital trash, deals with oral sex—an act punishable by law in many areas of the world. Yet his cute, kanji-ish male and female icons manage to pull off Kisman's mission (if not the missionary position) in a way that could offend only the most sensitive. It's great art that gives viewers a great time. And isn't that what great sex is all about?

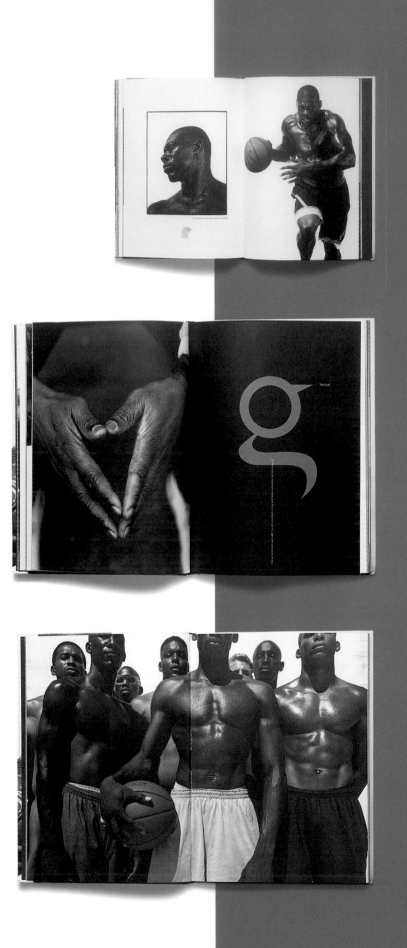

DESIGN COMPANY
Studio Jay

Veteran sports shooter John Huet's stunning photography and John Jay's skillful use of voluptuous typography set against a stark background combined to earn this book on street basketball the "Most Beautiful Book in Europe" award. Joshua Berger of Plazm Media assisted in its design.

DESIGNER
Max Kisman

Without knowing the title, "If 6 Was 9," one might think that this illustration Max Kisman created for a Japanese magazine's article on digital trash was just an interesting graphic arrangement. Paired with the name, however, its message becomes immediately obvious.

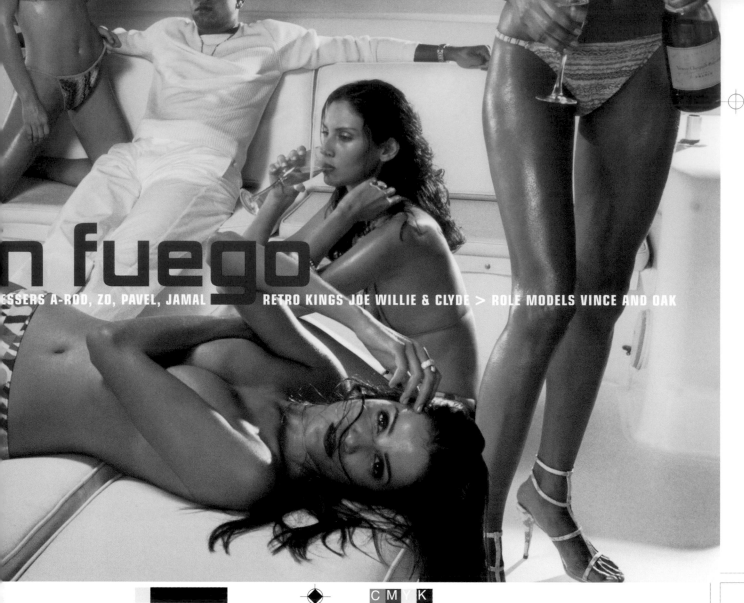

n fuego

ESSERS A-ROD, ZO, PAVEL, JAMAL RETRO KINGS JOE WILLIE & CLYDE > ROLE MODELS VINCE AND OAK

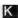 C M Y K

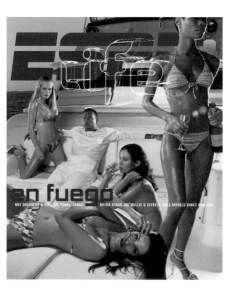

DESIGN COMPANY
ESPN, the magazine

This cover Peter Yates created for
ESPN, the magazine, a sports publi-
cation for the "MTV generation of
men," was rejected. Although there
is little difference in what one sees
in the approved version, the
addition of the skimpy bikini top got
the cover past ESPN's censors and
into subscribers' homes

DESIGN COMPANY
52mm

The image is nothing but a liquor store sign,
yet the way in which the sign's neon lights
reflect the evening sky's own natural palette
give this photograph by 52mm partner
Damion Clayton unexpected allure. The studio
catalogs such personal images for future use
and/or inspiration.

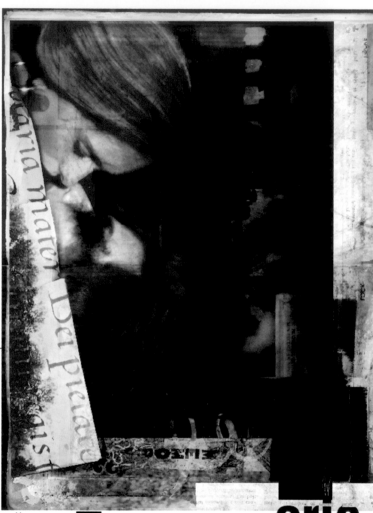

010.gallery

eric

eric dinver

success is not painting
beer logos

A decade ago, then 29-year-old artist Eric Dinver was told that his work was "too dark and personal" and that if he wanted to make a living at it, he would have to "paint photo-realistic racing cars with Budweiser logos on them". Without ever having painted a beer logo in his life, Dinver is now a highly successful artist/illustrator, recipient of the Silver Medal from the New York Society of Illustrators and prolific contributor to high-profile magazines around the world.

His long list of clients include Time-Warner Books, Columbia Records, *The New York Daily News, Newsweek*, TVT Records, *Playgirl, Raygun, Penthouse*, St. Martin's Press and Doubleday. In addition to appearing in the Communication Arts *Illustration Annual* since 1984, Dinver's work has also been profiled in Communication Arts and *Graphis* magazine.

dreamless studios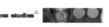

40 41

DESIGNER
Victor Cheung

IdN creative director Victor Cheung skillfully addresses the erotic quality of Eric Dinver's illustrations in this spread about Dinver's work.

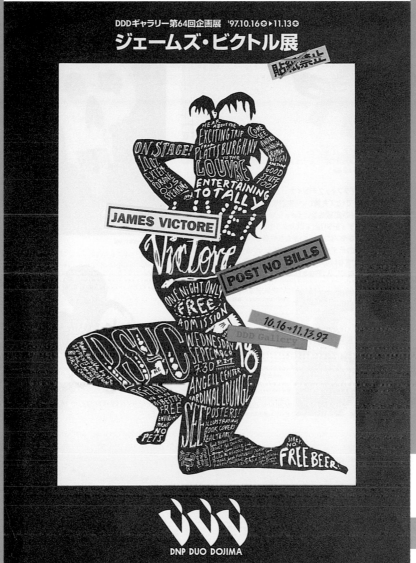

DESIGNER
James Victore

James Victore takes off on the tacky signs that often advertise live nude dancing to announce an exhibition of his posters and other work at a gallery in Japan.

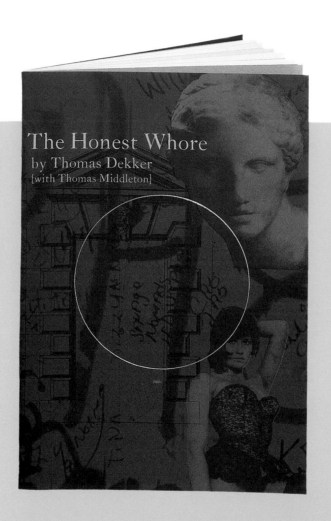

The Honest Whore
by Thomas Dekker
[with Thomas Middleton]

DESIGN COMPANY
Pentagram London

Angus Hyland pairs subtle grays
and classic icons with more sexually
explicit images to create a gently
erotic program for the Globe Theatre's
production of *The Honest Whore*.

OPPOSITE PAGE

DESIGN COMPANY
Modern Dog

A collection of sex kitten Ann-Margret
photos taken from throughout her
movie career transform her CD
packaging beyond seductive to give
it biographical significance as well.

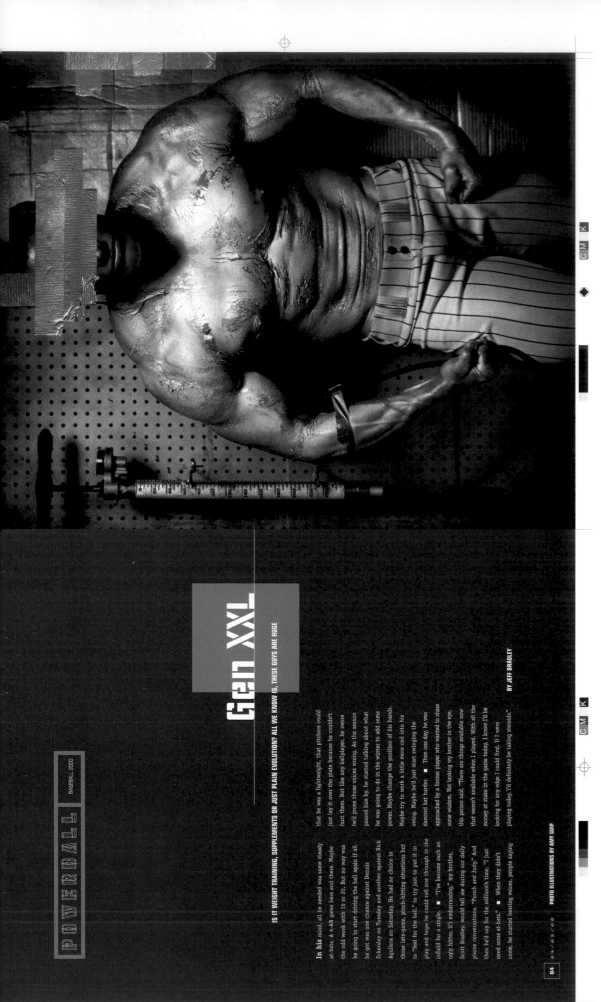

DESIGN COMPANIES
ESPN, the magazine and The BRM

Amy Guip's photo illustration of a pumped-up, silver-spray-painted American football player paired with duct tape and a tactile backdrop are enhanced with the designers' simple type treatment and use of complementary colors in this ESPN magazine spread. The article it illustrates discusses the huge size of today's football players.

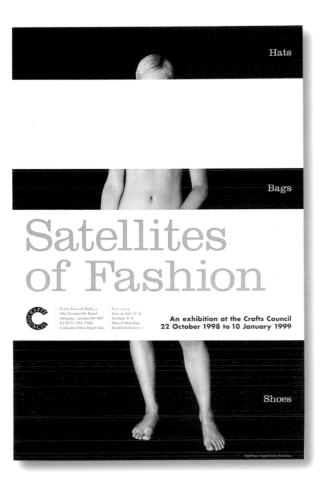

DESIGN COMPANY
Pentagram London

Angus Hyland employs a favorite
technique of movie legend Alfred
Hitchcock, leaving something to
the imagination in this Satellites
of Fashion poster and catalog he
designed for the Crafts Council.

<< Citrus (cont.): This is one of the reasons why we have supplied some of our chosen pieces as purely text based, to try and hopefully push the boundaries of what is provocative. It will be interesting to see how many contributors avoid the obvious taboo submissions for this book. >>

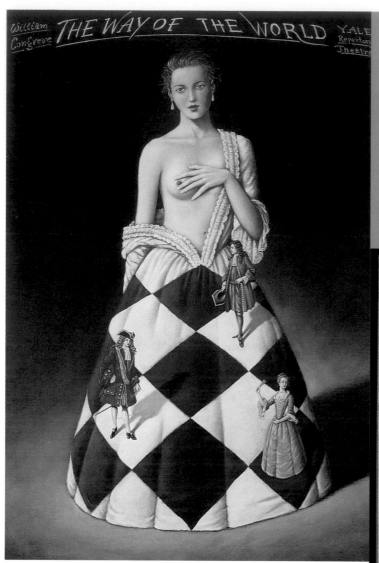

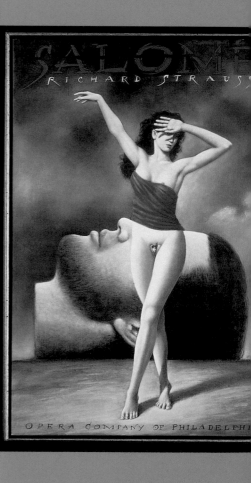

DESIGNER
Rafal Olbinski

Rafal Olbinski brings an intense passion to his work through rich colors, beautiful characters, and dreamlike settings, as seen in these posters he created for the Yale Repertory Theatre and the Opera Company of Philadelphia.

 "<<< **Dann DeWitt / titanium:** Provocation is what you experience when your body confirms your mind's suspicions. >>>"


DESIGN COMPANY
Pyro Brand Development
CREATIVE DIRECTOR
Todd Tilford
WRITER
Todd Tilford
ART DIRECTOR
Terence Reynolds
PHOTOGRAPHER
Richard Reens

"A series of ads relies on rebellious attitude to create both sex appeal and a strong identity for this fashion line."

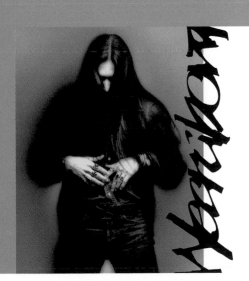

DESIGN COMPANY
Pyro Brand Development

CREATIVE DIRECTOR
Todd Tilford

WRITER
Todd Tilford

ART DIRECTOR
Terence Reynolds

PHOTOGRAPHER
Richard Reens

A series of ads relies on rebellious attitude to create both sex appeal and a strong identity for this fashion line.

ART VS DESIGN

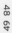

DESIGN COMPANY
Sagmeister Inc.

This image was created in Photoshop
to illustrate a chapter discussing
design versus fine art in the book
WhereIsHere. Although the image
tends toward the outrageous and
compelling, the subtle wash of
lighting across the body and the
figure's cross-like posture give it an
overwhelmingly seductive quality
as well.

DESIGNER
Max Kisman

Animated screen savers that Max
Kisman developed for an exhibition
in Amsterdam present a totally
different approach to sexuality from
most of the examples in this
section. His lusty graphic figures
offer some comic relief via their
fornication efforts.

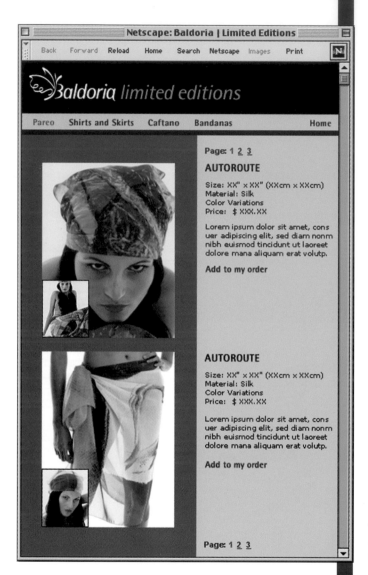

DESIGN COMPANY
Waters Design

This Web site for Baldoria fashions brings glamour to the Internet through compelling photography that quickly draws viewers in and rich, warm, colors that radiate sensuality.

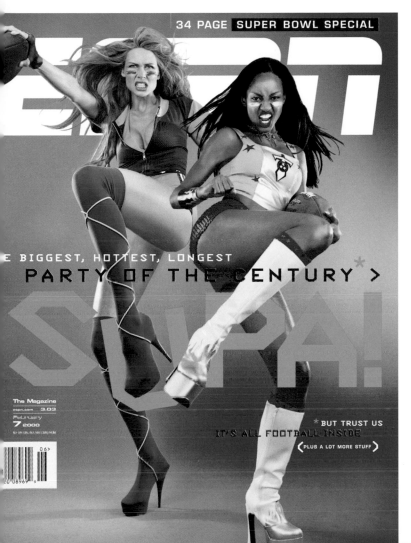

DESIGN COMPANY
ESPN, the magazine

Bright colors, hot pants, stiletto-heeled boots, and high-stepping cheerleaders help Peter Yates and Henry Lee "get jiggy" in their action-packed cover and spread that are brimming with sexuality.

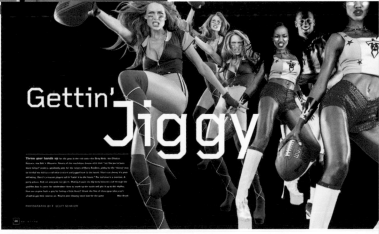

Gettin' Jiggy

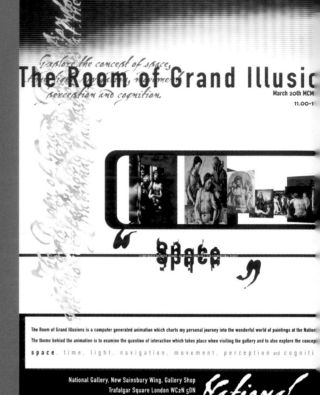

DESIGN COMPANY
Citrus

"The Room of Grand Illusions" is one of a series of seven posters that Citrus created for an exhibition by Junaid Kiayani at the National Gallery in London. The Room of Grand Illusions project used a VR walk-through animation to chart a journey into the world of paintings at the gallery. The animation's theme examined the question of interaction that takes place when visiting the gallery and explored the concept of space, time, light, navigation, movement, perceptions and cognition. As Citrus designers Steve Meades and Jim Cooper said, "It's deep stuff!"

DESIGN COMPANY
Stoltze Design

This lavishly produced CD package combines capti-vating illustrations, earthy colors, and hand-scripted text for sensuous results. The designers describe the Moors' music as "incredibly pagan."

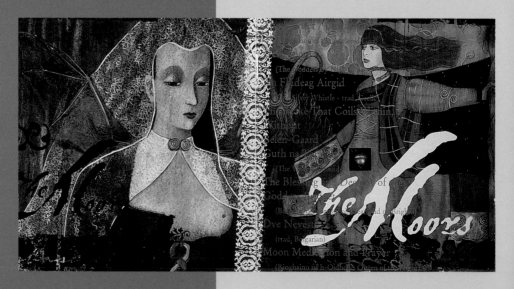

DESIGN COMPANY
Oh Boy! It's a Design Company

Every movie topic from death to suspense is addressed in this poster announcing a competition for filmmakers. Yet, when the 24-by-36-inch (60.96 x 91.44cm) poster is folded down to its 9 by 6 inch (22.86 x 15.24cm) mailer size, its numerous themes are likewise reduced to one unmistakable subject: sex.

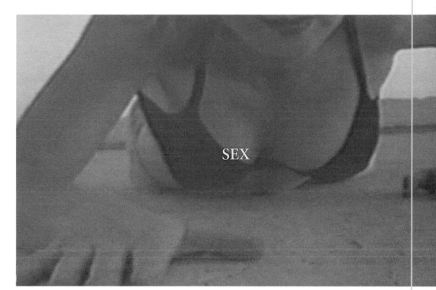

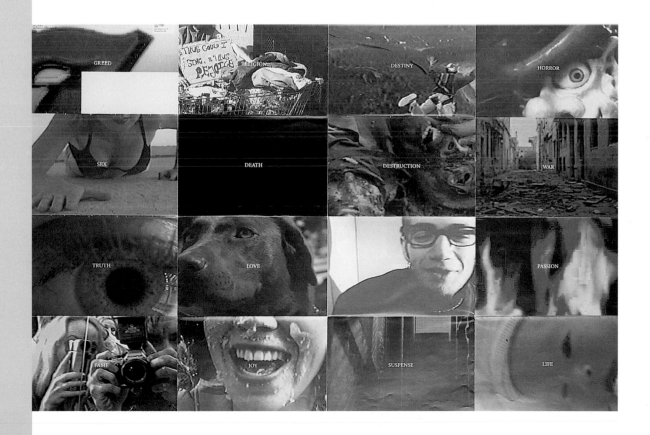

INCENSIN

I/in sens/ vt. to make very angry; fill with wrath; enrage.

If the pen is mightier than the sword, as Edward Bulwer Lytton said, then a skillfully executed design must carry the power of a neutron bomb. Unrestricted by language barriers and with the ability to communicate across a wide spectrum of education levels, design can goad viewers to commit all sorts of deeds—even acts of brutality. Hendrik Werkman's tragic end demonstrates the extreme in viewer savagery. He was revered in design history as the brains behind such groundbreaking typographic experiments as those exhibited in his publication "The Next Call". But in 1945, just days before Holland's liberation, the 53-year-old Dutchman was shot by the Nazis and much of his work was destroyed. What drove the Germans to murder Werkman, even as the Allies marched the last few steps to their door? They were furious over the clandestine publications that he continued to produce throughout their occupation. Operating under the Blue Barge imprint, Werkman put out 40 issues of his subversive broadside right under the Nazis' noses. Werkman no doubt knew the ramifications of what he was doing. After all, the Nazis were not known for leniency toward anyone expressing contempt for Third Reich policy. But the general audience can be very fickle when it comes down to what exactly will provoke its wrath. Some designers have been totally taken by surprise at the severe castigation a seemingly innocent creation brought on. One of the most notable examples of this in recent memory has to be Michael Salisbury. He incensed the public by filling the needs of his client, R.J. Reynolds, too well when he developed one of the most successful characters in advertising history—Joe Camel. Unfortunately, "way cool" Joe was way too appealing to children. He sent them a message that smoking was a good thing. This brought the U.S. Federal Trade Commission down on RJR, charging the tobacco manufacturer with unfair advertising practices. It also brought the public down on Joe's creator. In hindsight, Salisbury surely understands why people reacted as they did. However, Sean Adams and Noreen Morioka of AdamsMorioka, Los Angeles, are still amazed at the response generated by a paper promotion they created. The client loved it and said it got excellent results. But some choleric members of the design community had a much different perspective. In the promotion, a parody of the cult classic *Valley of the Dolls* (page 56) the AdamsMorioka staff portrayed the movie characters themselves rather than hire models for the job. At the time, the studio was getting a lot of worldwide media attention for its work. Jealous colleagues charged that in taking on the movie star roles, Adams and Morioko were actually revealing their super-sized egos. The real reason why no models were hired was that the client could not afford them. But that didn't seem to make a difference to those who were sure it was because Adams and Morioka had "gone Hollywood." A flurry of heated letters to design publications and the studio itself ensued. These examples offer just a brief glimpse at the extreme reactions audiences can have to visual provocation. They also demonstrate that, whether or not it is done intentionally and whether or not the response is justified, design's potential to incite viewers is undeniable. Consequently, when creating a piece no matter how innocent your intention, try to anticipate every possible ramification. And then still be prepared for the unexpected.

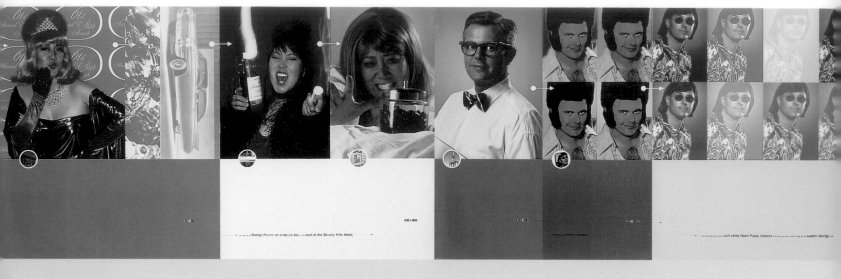

DESIGN COMPANY
AdamsMorioka

This seemingly saccharine promotion upset
the design status quo because, critics
charged, it proved that Sean Adams and
Noreen Morioka had "gone Hollywood."
The truth was, the client's budget could not
accommodate the cost of hiring real
models so the AdamsMorioka staff filled in.

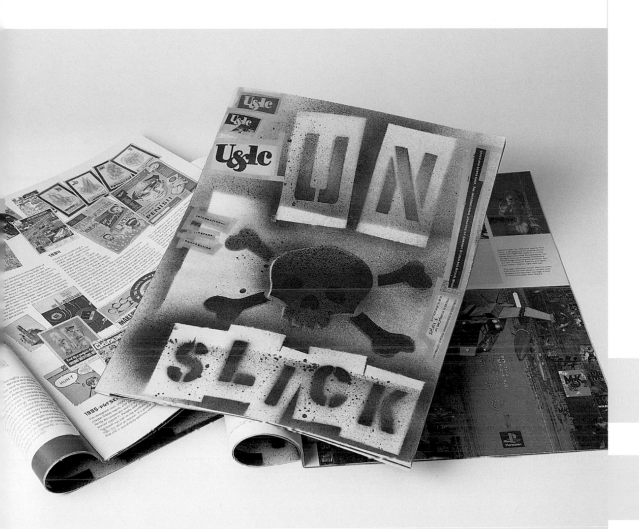

<<< McCarthy (cont.): Provocation is a relative thing. If the communication's recipient is provoked, then it's provocation. If not, no provocation exists, even if the sender's intentions are to provoke. >>>

DESIGN COMPANY
Modern Dog

The creators say that this "Unslick" issue of *U&lc* vexed designers who generally expect the magazine to present the beautiful, refined world of typography rather than the crude, hand-drawn lettering of Art Chantry, Modern Dog and other such "raw" work.

DESIGN COMPANY
Plazm

"Goat People" is the centerfold of *Plazm*, an alterna-
tive arts magazine published by Plazm studio. It
illustrates an article on situation soap operas in which
writer Sara Xel Thompson imagines a soap opera that
"would push even today's world of laissez-faire broad-
casting to its breaking point." Just like Thompson's
fictional program, the illustration, by Linda Reynen,
has something to offend everyone.

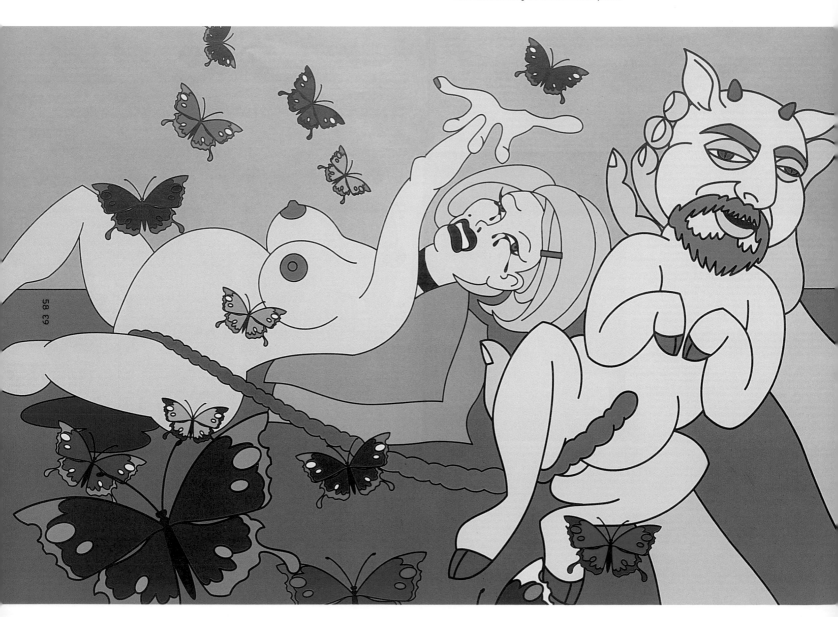

58 59

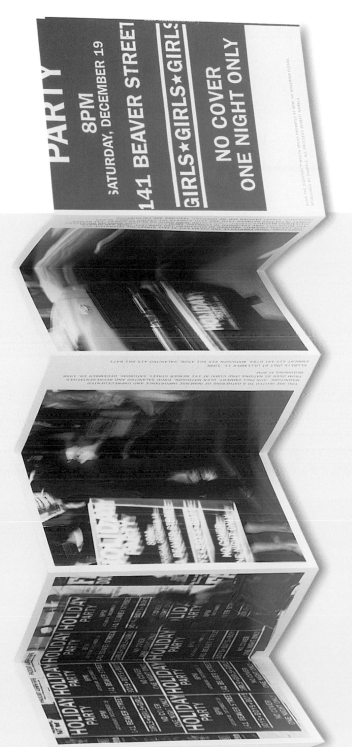

DESIGN COMPANY
Oh Boy! A Design Studio

At first glance, this studio's holiday party invitation seems innocent enough. The snickers (or outrage) come when viewers notice the promise of "girls, girls, girls" and that the party takes place on Beaver Street. The designers say that they "evoked the spirit of the burlesque" in their invitation.

<<< McCarthy (cont.): As a vice, provocation is fickle. One era's provocation is a subsequent era's titillation, which in turn becomes another era's convention. Another way to say it is: Hopelessly insane becomes genius becomes avant garde becomes progressive becomes mainstream becomes passé becomes nostalgic. >>>

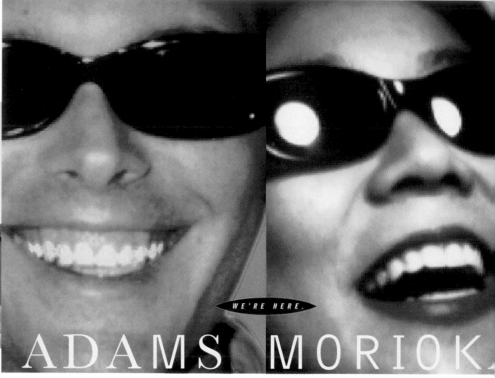

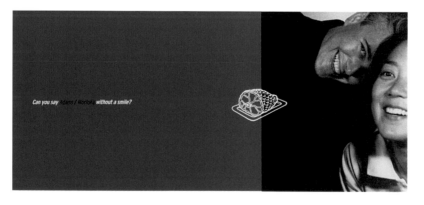

DESIGN COMPANY
AdamsMorioka

Sean Adams and Noreen Morioka say they developed this seemingly benign series of postcards to communicate a clear message of who they are and what they stand for. Against the advice of several noted designers, however, they used highly retouched images of themselves, mainly because at the time they were better known personally than for their work. Living in Los Angeles, surrounded by imagery and the packaging of celebrities, it seemed obvious. Yet the response was a shock. Clients loved the cards, even sending back their own versions embellished with Dali facial hair and halos. The design community in general, however, behaved as if the studio had broken a cardinal rule. Responses ranged from "You can't use yourself on a promotion" to "Your cheery disposition makes me sick."

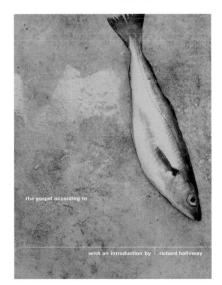

DESIGN COMPANY
Pentagram London

Anytime one introduces religion into design, there are bound to be repercussions. Imagine, then, what might happen when a designer is given the assignment to redesign the Bible itself. Angus Hyland's thought-provoking interpretation of the books of the Bible (created for Cannongate Books Ltd.'s Pocket Canons) range from incensing to serene and beautiful.

<<< McCarthy (cont.): Sex. Violence. Race. Gender. Religion. Nationality. Politics. Class. Media. Drugs. Commerce. What are the opportunities for tomorrow's provocateur? Is it okay to provoke for provocation's sake? What is the desired outcome? >>>

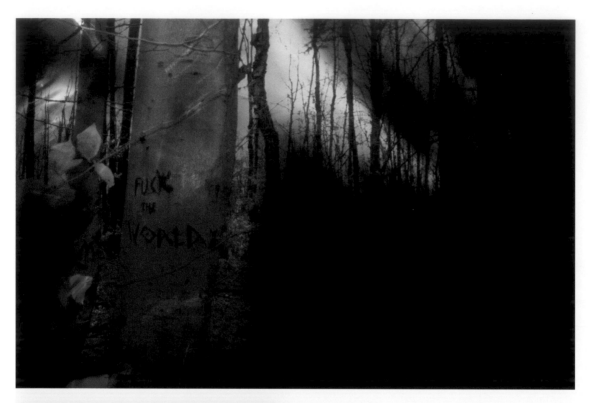

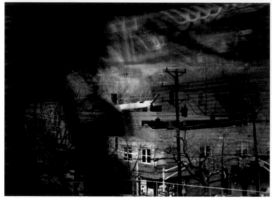

DESIGN COMPANY
52mm

Partners Marilyn Devedjiev and Damion Clayton maintain an archive of personal photos that they use for inspiration or future projects. The two shown here were taken by Devedjiev. The ominous message of the forest setting (above) incenses anyone who cares about the environment, for obvious reasons. The offense committed by "neonjersey," (left) however, is not so apparent. In fact, many might consider the photo compelling and alluring. Devedjiev explains that she thinks it is detestable simply because she doesn't like New Jersey.

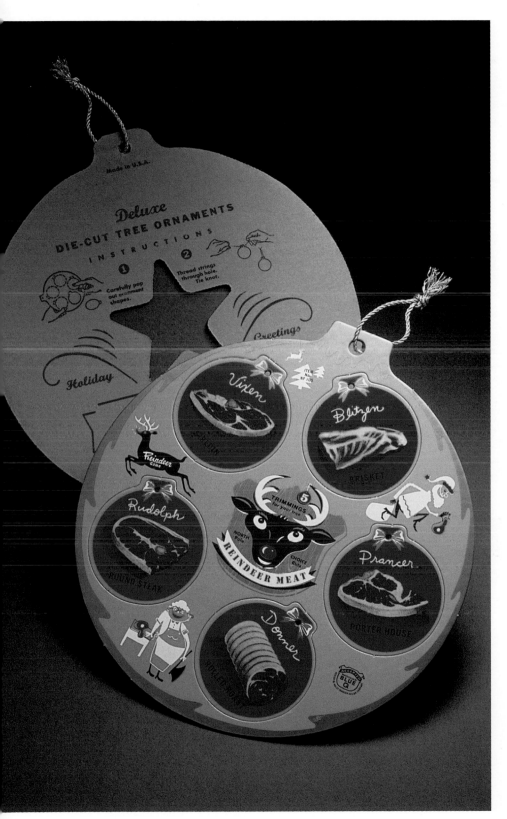

DESIGN COMPANY
Haley Johnson Design

"Reindeer Meat" offends vegetarians, while hunters and carnivores agree they are the best ornaments ever, according to the designer of this humorous, yet slightly offensive take-off on the traditional Christmas tree decoration.

HEAD
BANG
ER

"An exciting and blackly comic thriller, lobbing incendiaries at both the dark corners and sacred cows of modern Ireland.... Read it now before it comes to a cinema near you."
—*Sunday Independent*

By Hugo Hamilton

DESIGN COMPANY
Stewart A. Williams Design

This book cover (left) and newspaper pullout (below) deal with a subject that many would rather not think about—violence against women. Stewart Williams' work might be considered exploitative, on the one hand. Yet the designer offers a hard-boiled, realistic view of just how ugly and serious the crime is.

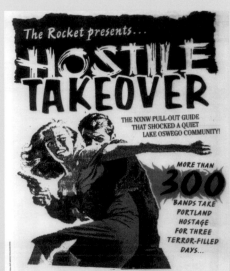

Sean Adams and Noreen Morioka say they strive to maintain a "veneer of harmless aesthetic" while playing with subject matter that's not so nice and sweet. This poster for their lecture at the Orange County (California) AIGA, for instance, employs obvious symbols for the region. The twist, however, is the lemon that represents Morioka. She is of Japanese descent.

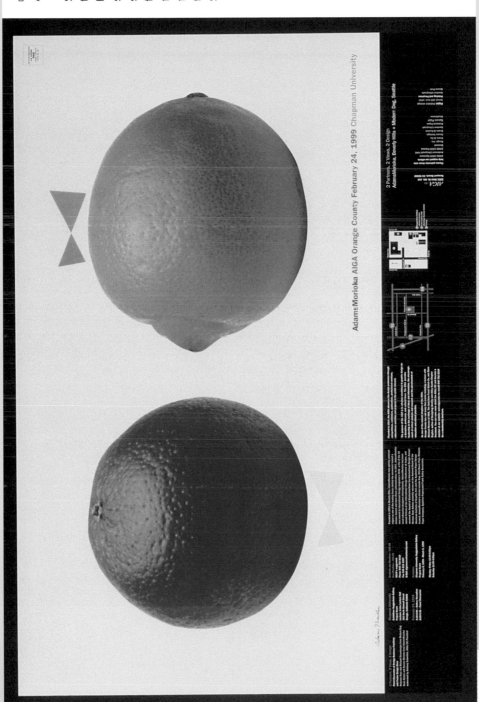

<< McCarthy (cont.): I believe that the frontier for future provocation lies outside of the twentieth century's definitions, although we must certainly acknowledge the many terrific provocations of these late, great provocateurs: Marcel Duchamp, Buckminster Fuller, Salvador Dali, Antoni Gaudi, Josephine Baker, Eric Gill, Andy Warhol, and select others. Stimulations are still attempted by the occasional provocations of the Guerilla Girls, Bureau, Jonathon Barnbrook, Stefan Sagmeister, Art Chantry, Oliviero Toscani, and others. Fine artists Carolee Schneeman (direct genitalia prints), Robert Mapplethorpe (homo-erotic photography), Andres Serrano ("Piss-Christ"), Paul McCarthy (fecal performance pieces), Joel Peter Witkin (pictures posed with cadavers), and so on, have too limited an exposure in the design community to achieve their deserved provocative status, so back to the future. >>

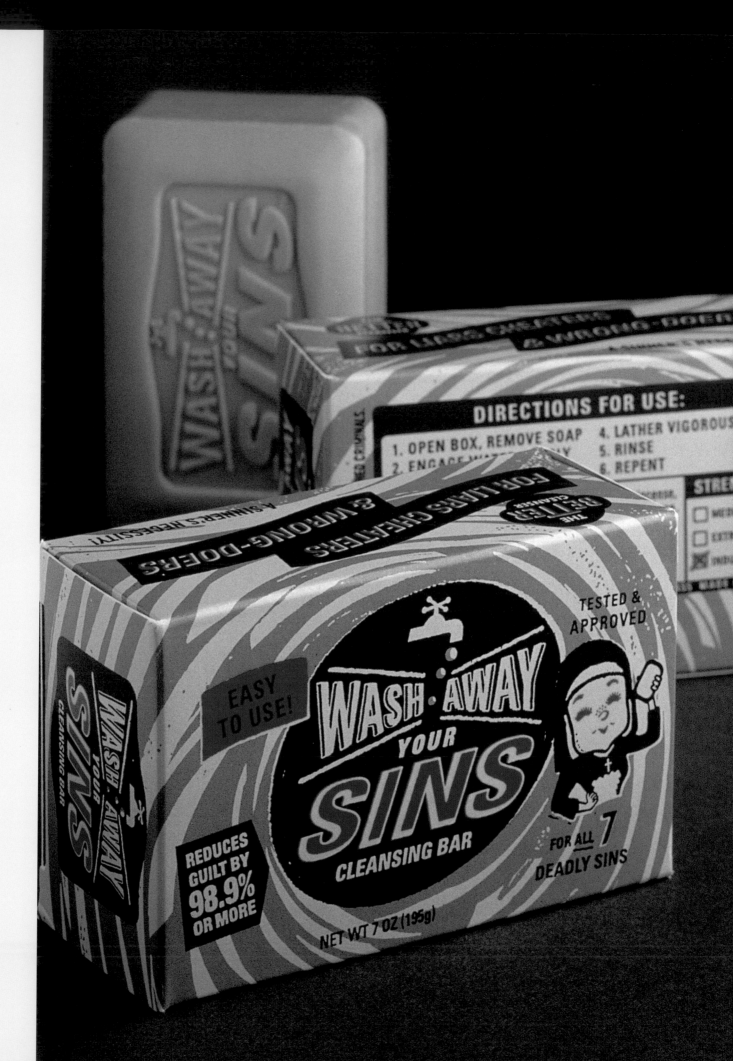

67 99

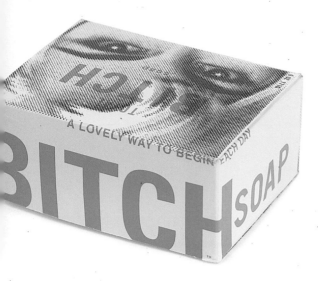

DESIGN COMPANY
Haley Johnson Design

Haley Johnson's line of soaps for Blue Q have received a variety of responses. When Blue Q showed the "Total Bitch" line at one trade show, it caused so much stir that the company was asked to not return the following year. On the other hand, other equally inventive soaps in the line with names like "Wash Away Your Sins" (opposite) and "Dirty Girl" have enticed throngs of smiling consumers to happily plunk down their cash.

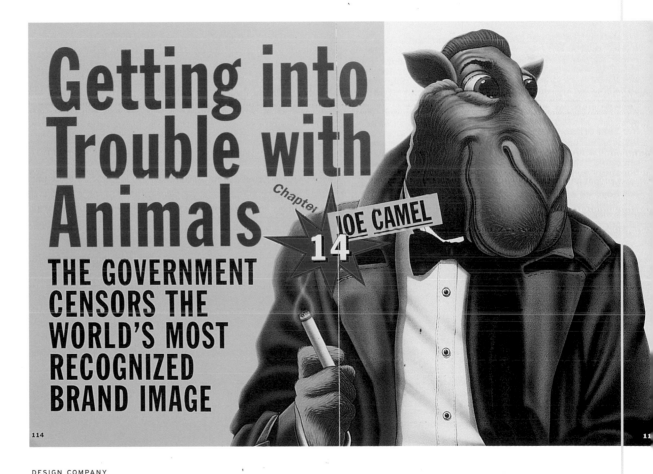

DESIGN COMPANY
Mike Salisbury Communications

Mike Salisbury's popular character, Joe Camel, may have been "way cool" but he certainly made things hot in the advertising arena. The U.S. government charged Salisbury's client, R.J. Reynolds, with unfair advertising practices after Joe proved way too popular with youngsters. Salisbury addresses the controversy in his book "Confessions of an Art Director," from which this spread was taken.

SHOCKING

chapter 4

/shok'-ing/ v.t. **a:** to cause an emotional or mental shock to **b:** to give painful offense to

We exist in a world filled with self-appointed censors who would deny others the right to experience anything that gives their own sensitivity the slightest jolt–people whose tolerance level ranges from 0 degrees to not much higher. Despite the absurdity of the censors' desire to force their narrow-minded views on others, the power they exert can sometimes be mind-boggling. **Grave consequences can befall those who dare to defy them.** Yet that doesn't stop some designers from constantly taking swipes at the self-righteous order. They delight in making these officious meddlers squirm in discomfort by using shocking, disturbing images in their work, or by presenting unadulterated views of taboo topics. It's sometimes done in fun. Often, however, the intent is to make a serious point in a manner that the audience can't ignore or forget, such as James Victore's humorous depictions of fornicating flies and rabbits in posters that promote safe sex (page 70). Or the simple, unembellished brochure created by Modern Dog for the Seattle Public Health Department that reminds drug users to use clean needles and then shows them the correct way to inject themselves (page 71). To put a sensational image or theme to good use, however, designers must observe that there is a fine line over which one never crosses—one that marks the boundary between something that pushes the limits of acceptability and that which is totally inappropriate. As an example, consider Nick Ut's haunting photo of the Vietnamese child fleeing nude down a dirt road, face distorted in agony as she tries to escape the napalm that is burning holes through her body. Only the most callous would not be moved by this shocking, grotesque reminder of how war affects the innocent. Given its ability to galvanize viewers' attention and make a lasting impression, then, is this distressing image and others like it suitable for the designer's visual toolkit? It all depends on context. Use Ut's photo in something as flippant as an ad for running shoes and the designer would likely–and justifiably–attract only scorn. The client who allowed the designer to exercise such bad judgment would probably suffer, too. Yet as the centerpiece of a poster reminding us of war's atrocities, the photograph would make a stirring, unforgettable statement. **It would also take on added meaning, traveling far beyond shocking its audience to challenge them to take action on the side of peace.**

KING

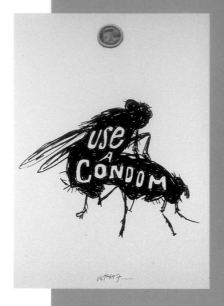

DESIGNER

James Victore

James Victore's "Use a Condom" series of posters use some of nature's most prolific fornicators to get the message across.

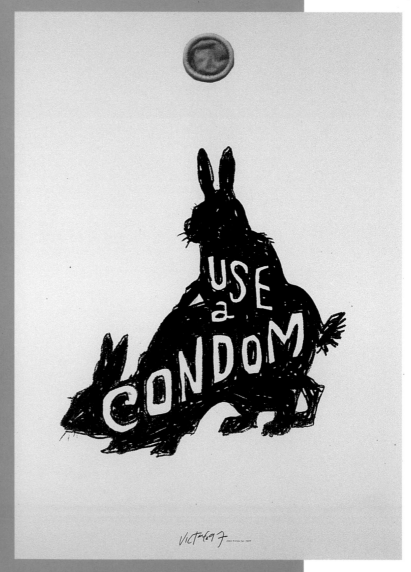

muscling and skin popping

Information for Injection Drug Users

Hard-to-hit veins? Abscesses?

Talk to our abscess and vein care specialist at the needle exchange. Get expert advice and helpful hints to reduce your risk of getting nasty abscesses and life-threatening infections. Ask Needle Exchange staff for times and locations. Or visit the new medical clinic at the downtown needle exchange. The clinic is open Monday through Friday from 1:30pm to 4:30pm. Walk-ins welcome.

Public Health
Seattle & King County
HEALTHY PEOPLE. HEALTHY COMMUNITIES.
Needle Exchange Program
1511 Second Avenue
Between Pike and Pine in downtown Seattle
Open Monday-Friday 1:00pm-5:30pm,
Saturday 2:00pm-4:00pm
Call (206)**205-7837**(STDS) for other sites and times
TTY 206 296 4843

Available in alternate formats 7/00

What is muscling?

Muscling is when you inject into muscle instead of a vein. Most people muscle in the upper arms or legs.

What is skin-popping?

Skin-popping is when you inject between skin and fat layers. Also called "subcutaneous" or "sub-Q," it is injecting the drug just underneath the skin.

Why do people muscle or skin-pop?

Lots of reasons. Some people just don't like to inject right into a vein. Others have a hard time finding their veins. For some, trying to hit a vein gets so frustrating that they just give up and shoot anywhere they can. Some do it because drugs absorb more slowly this way. Muscling and skin-popping give you less of a "rush," but the effects of the drug may last longer. Some folks don't care about the rush. They're just trying to keep from getting dope sick. Finally, some people muscle or skin pop to reduce their risk for overdosing.

Use new clean equipment!

New Clean Syringe!

New Clean Cottonballs!

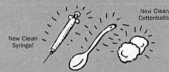

What are the harms of muscling and skin-popping?

All injectors are at risk for infections related to using needles. Muscling and skin popping allow germs to "sit" inside muscle and fat tissue or under the skin. These are great places for abscesses and other infections to brew. Infections in these areas can be very serious. They can also spread to the blood, bones, heart and other places in the body. Some of the worst infections include wound botulism, tetanus (also called "lockjaw") and necrotizing fasciitis ("flesh eating disease"). If not treated quickly, these and other infections can become life-threatening and result in death.

How to clean the injection site.

Step One: Take an alcohol pad and wipe back and forth where you plan to inject. (This will probably be your arm.) You want to press kind of hard this time. Use as many pads as you need to get the dirt off your skin. But don't stop here! *You're not done!* That's why wipes come two to a pack.

Step Two: Now grab a new pad, and press down over the spot where you're going to inject. This time, wipe in a circle. Start with small circles and make bigger circles as you go. This pushes any leftover dirt and bacteria on your skin outward from the spot where you're going to shoot.

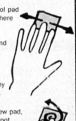

DESIGN COMPANY
Modern Dog

The debate wages on over whether public health departments should provide clean needles to drug users. Critics charge that it encourages their addiction; proponents say that addicts will use drugs no matter what, so the health department's job is to make it as safe as possible for them. This brochure instructing users on the safest way to inject themselves, designed by Modern Dog for the Seattle Public Health Department, makes no comment on the issue one way or the other. It takes an unadorned approach to the topic in both its content and its presentation.

<<< McCarthy (cont.): A case study in relative provocation: My neighbor's garage was "tagged" (painted with graffiti) a couple nights ago. Mine, opposite theirs in the alley, a large recently painted canvas of creamy yellow with taupe, purple, and mint green trim, wasn't. >>>

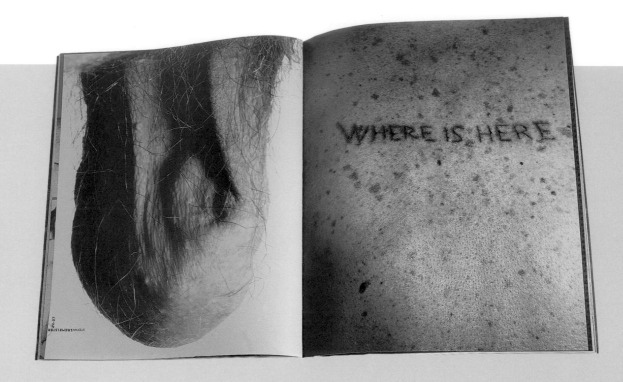

DESIGN COMPANY
Sagmeister Inc.

This title spread quickly sets the tone for Scott and
Laurie Haycock Makela's book *WhereIsHere?* (Booth
Clibborn Publishing) in which the authors focus on what
they see as the heart of modern communication: the
designer's search for identity. Sagmeister states his view
clearly with a very up-close-and-personal look at his own
"dangling things," as he calls them. On the opposite
page, he reiterates the profundity of the authors'
question by having it carved into his back, literally.

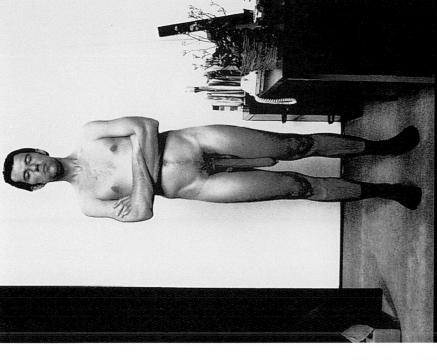

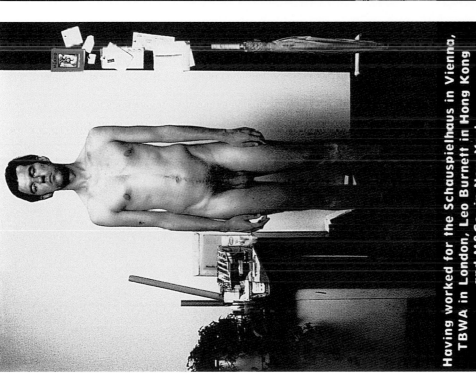

I am now opening up my own company.
SAGMEISTER Inc.
222 West 14th Street New York City, NY 10011

Having worked for the Schauspielhaus in Vienna, TBWA in London, Leo Burnett in Hong Kong and M&Co. in New York,

DESIGN COMPANY
Sagmeister- Inc.

DESIGNER
Stefan Sagmeister

This piece shows that hardly anything is sacred when it comes to what can be the butt of a Stefan Sagmeister joke–even the designer himself. The direct mailer was used to announce Sagmeister's move from working for another to opening his own studio.

<<< McCarthy (cont.: Did the graffiti artist not have time? Did s/he respect the evidently "artistic" way I had painted the thing? Is mine being saved for when the graffiti artist has an appropriate color with which to have an aesthetic dialogue on the yellow canvas? > > >

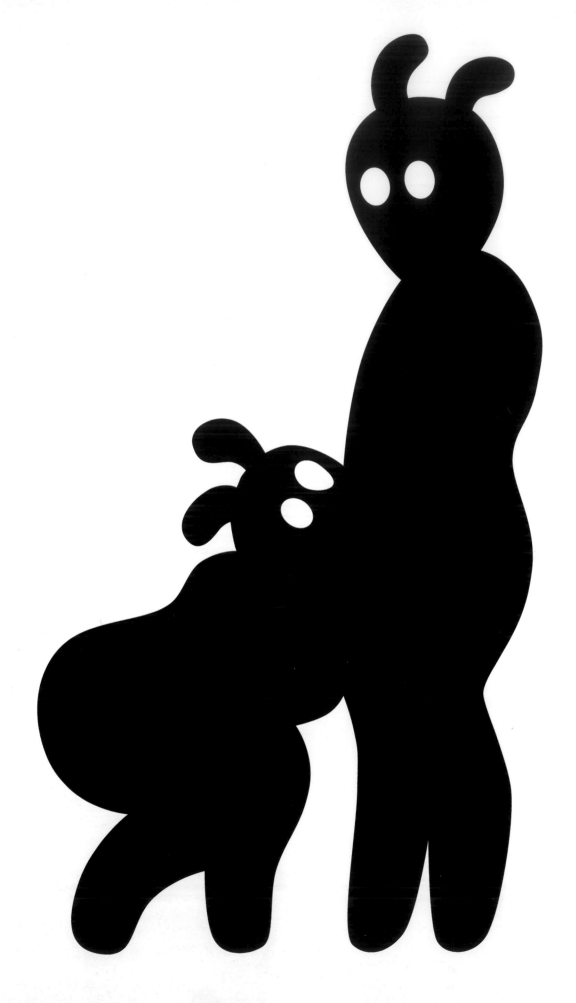

DESIGNER
Max Kisman

Ironically, the meaning may have
been too explicit for the *Wired*
magazine editors who rejected this
illustration Max Kisman created for
an article about using graphic icons
to replace words.

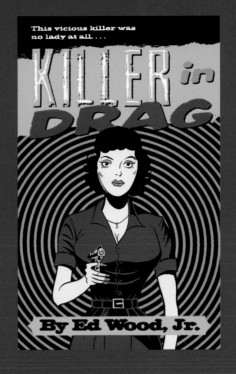

DESIGN COMPANY
Stewart A. Williams Design

Many viewers would consider this book
cover announcing a gay rights forum
(above) and ad about a murderous trans-
vestite (top) insidious, both for their
subject matter and for the blunt manner
in which the designer presents them.

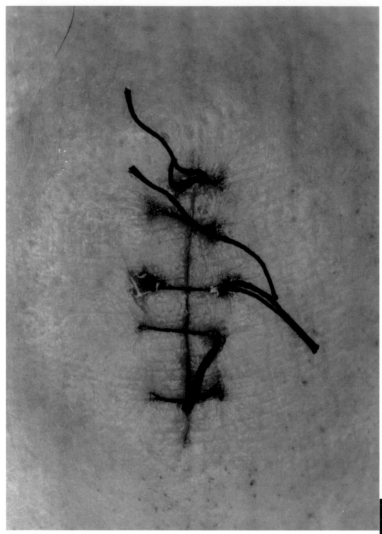

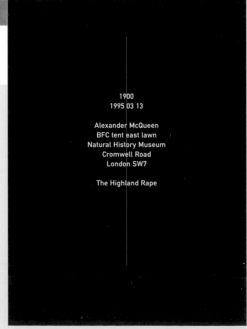

1900
1995 03 13

Alexander McQueen
BFC tent east lawn
Natural History Museum
Cromwell Road
London SW7

The Highland Rape

DESIGN COMPANY
Pentagram London

The fashion press has dubbed British designer
Alexander McQueen the "enfant terrible" of the
industry, in part for his riveting, often contro-
versial runway shows. The "Highland Rape"
collection of 1995 was no different, inspired by
"scars left on the Scottish people from the
clearances imposed on the country throughout
its history," McQueen says. Pentagram London
partner Angus Hyland capitalizes on McQueen's
theme as motivation for his own unsettling, yet
compelling invitation to the show.

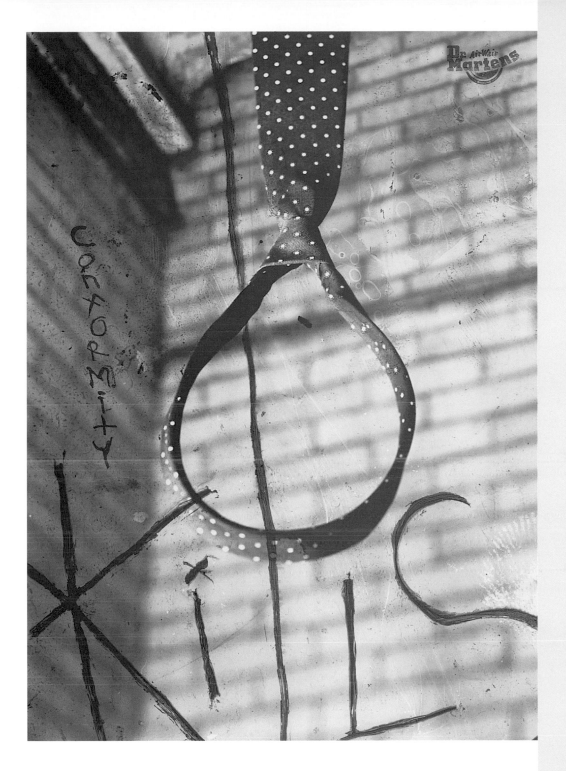

DESIGNER
Pyro Brand Development

CREATIVE DIRECTOR
Todd Tilford

WRITER
Todd Tilford

ART DIRECTOR
Eric Tilford

PHOTOGRAPHER
James Schwartz

A standard man's necktie becomes
an ominous symbol of conformity in
this poster for Dr. Marten's shoes.

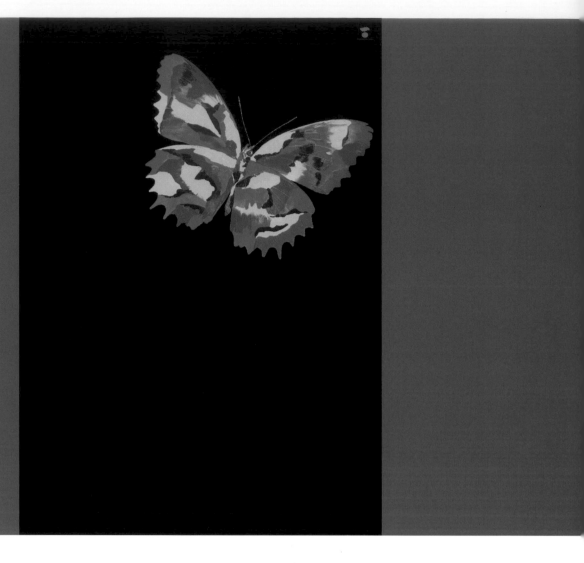

DESIGN COMPANY
Wang Xu and Associates

Wang Xu's "Peace" poster for the
Taiwan Poster Design Association 2000
is deceptively disturbing. At first glance
the image of a soaring butterfly sends
a message of serenity—then one
notices its militaristic coloring.

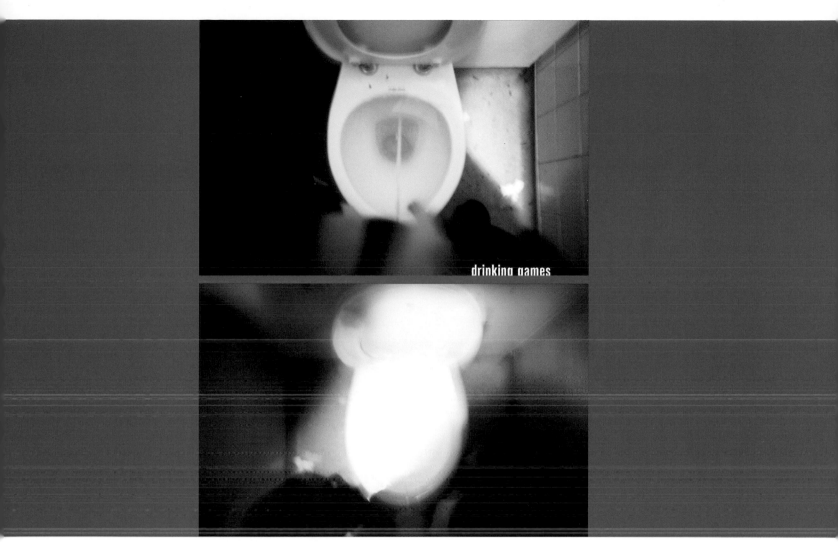

drinking games

A. Before

B. After

DESIGN COMPANY
52mm

Damion Clayton's views on two serious
issues in the United States, the plight
of senior citizens and binge drinking,
are powerfully conveyed through these
personal photographs and their simple
tag lines.

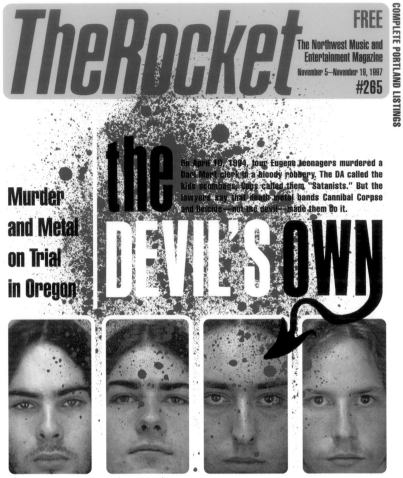

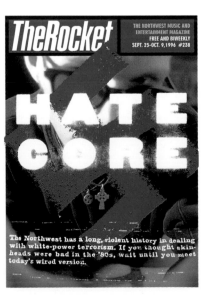

DESIGN COMPANY
Stewart A. Williams Design

Stewart Williams' covers and spreads for the alternative magazine *The Rocket* leave no doubts about the subject matter, as the designer tackles each with a no-holds-barred visual tactic.

DESIGN COMPANY
Modern Dog

Amphetazine is a Seattle-based magazine for gay men who shoot up crystal-methazine. Its intent is to educate readers about the dangers involved and, for those who choose to continue their drug use, to show them how to do it in the safest way possible. Modern Dog's designs adopt the same attitude as the editorial content, taking a straightforward, almost crude approach to the subject.

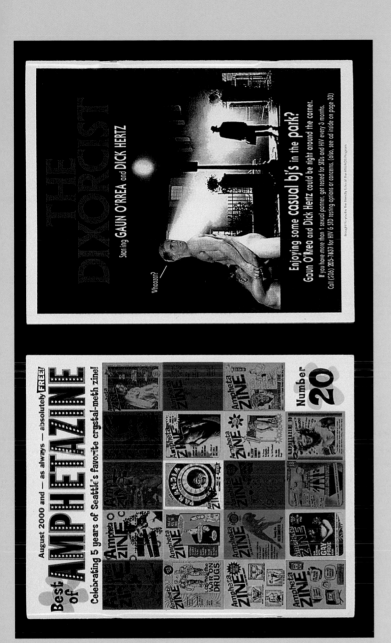

Q: What is the value (or is there any?) in bringing provocation out in your work?

Citrus: A provocative aspect to your work, unless specifically produced to provoke outrage or like reaction, conceals within it a powerful hidden level of viewer interaction. All art, be it design-, illustration-, or photography-based, exists to create an effect in those who view it. If a piece of work fails to stir a single emotion, then it fails to fulfill its objective; nothing is produced to have NO effect, there would be no point in doing it! If a piece of work can really tap into a person's mind, it has the ability to work on a far deeper and more effective level. >>>

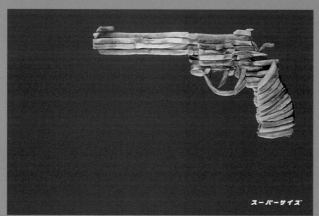

スーパーサイズ

DESIGN COMPANY
Plazm

These images were originally created for the Japanese magazine *IDEA* for a special issue on American design. The designers maintain that while many view America as a land of guns and violence–a concept conveyed to the world via movies and other entertainment delivery systems–the country's deadliest export is in reality fast food.

OPPOSITE PAGE
DESIGN COMPANY
Sagmeister Inc.

Stefan Sagmeister's poster for an AIGA Detroit lecture was intended to show the pain that accompanies most design projects. The words were actually cut into his own body by an Xacto-wielding intern. Many found the poster disturbing, though not for the obvious reason. One panel of judges summed up the feelings of many of their peers when they rejected it from a design competition for being "too self-serving."

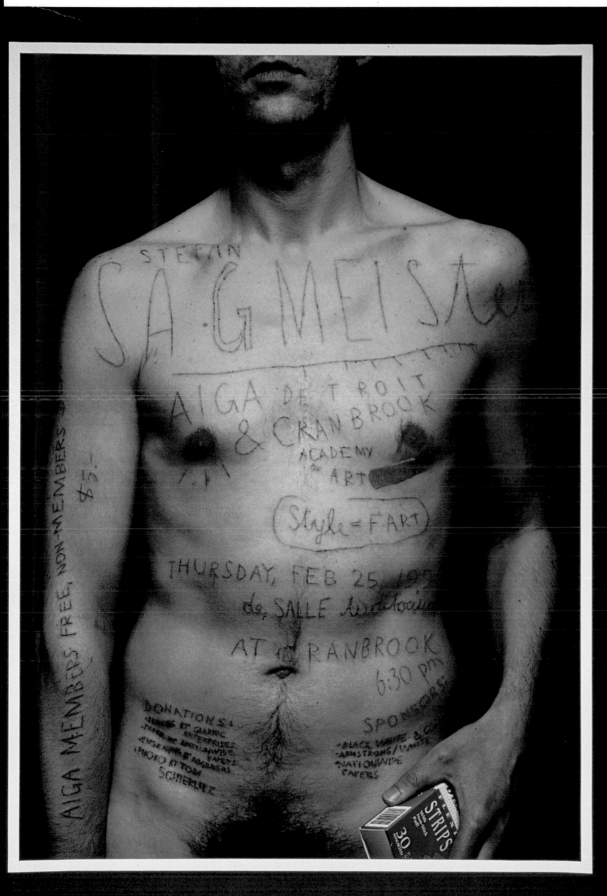

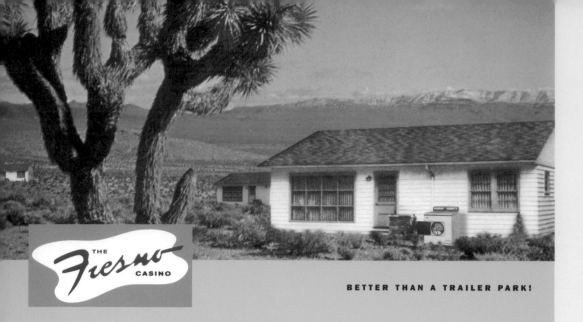

THE Fresno CASINO

BETTER THAN A TRAILER PARK!

a clean mattress on every floor

real nice rooms

picnic lunches available – call 666

exotic cuisine

nightly entertainment

a barking dog at every unit

swimming

do your washing in the front yard

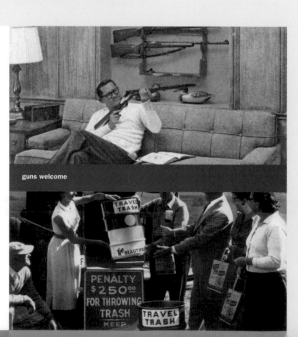
guns welcome

DESIGN COMPANY
AdamsMorioka

In this case study of a new casino developed for Appleton Papers, the designers decided to "walk down the cinema verite path" by playing with the attributes usually associated with trailer trash. Partners Sean Adams and Noreen Morioka say that their intent was not mean-spirited, but rather they were aiming for a tongue-in-cheek look at the reality of Las Vegas when they created this Web site. When the designers show the work at lectures, it is usually met first with laughter, followed by silence, and then mumbling as viewers notice the "guns welcome" sign.

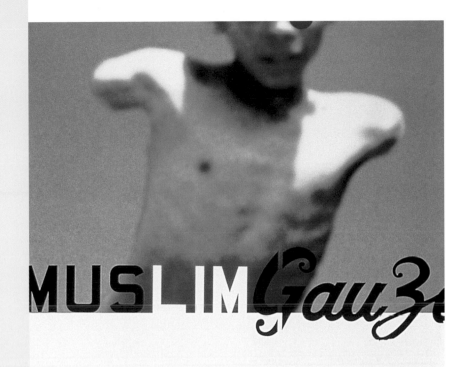

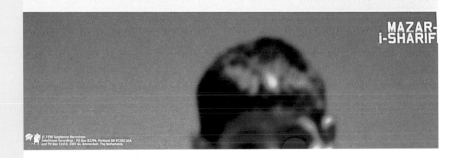

DESIGN COMPANY
Plazm

Muslimgauze's music is often described as "fake Arab ethnic-industrial"—an interloper from Manchester, England, who appropriates Middle Eastern sounds to create a self-styled musical hybrid. In this packaging for his Mazar-I-Sharif CD, the designers wanted to reveal an outsider's (Westerner's) perception of Middle Eastern politics.

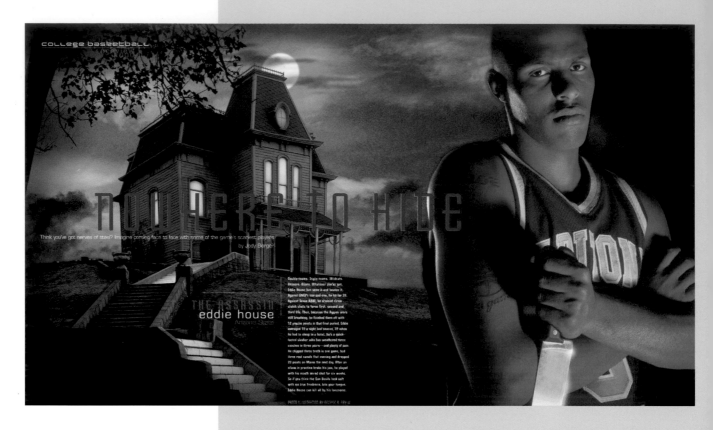

DESIGN COMPANY
ESPN, the magazine

"Murder and mayhem" is the
message of this *ESPN, the
magazine* spread about the
aggressive abilities of several
super-tough college basketball
stars. Movie buffs will quickly
recognize that Yvette Francis and
Peter Yates design is a takeoff on
Alfred Hitchcock's landmark
thriller *Psycho*.

OPPOSITE PAGE
DESIGNER
Rafal Olbinski

This semi-gory surrealistic poster
was created for a theatrical
production of *King Lear*.

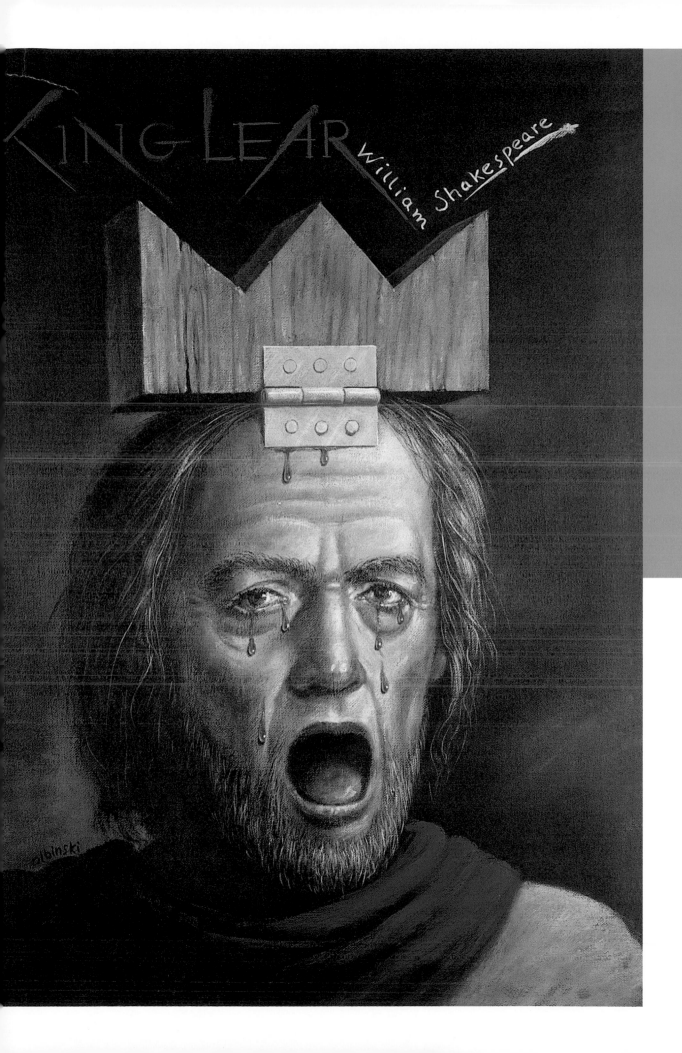

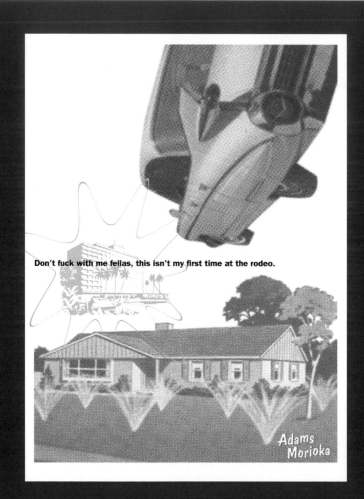

DESIGN COMPANY
AdamsMorioka

The designers were feeling backed against the wall and abused by the world. Still, they wanted to develop a poster for their upcoming lecture that was fun, playful, and portrayed some of the experiences they have encountered by virtue of the fact they work in Los Angeles. So they intentionally made the aesthetic as saccharine as possible, then threw their true sentiments into the mix by incorporating a line from the movie *Mommie Dearest*.

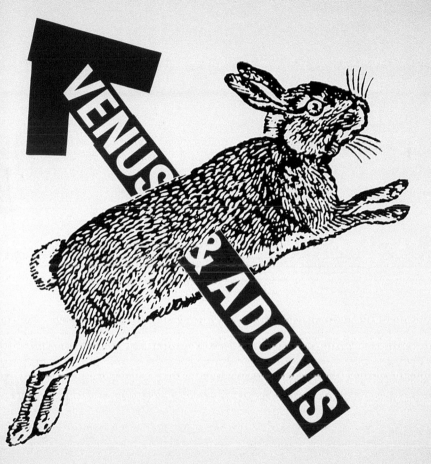

FREE

DESIGNER
James Victore

James Victore considers nothing sacred—even cute, furry creatures—as seen here in his poster for a Shakespeare Project presentation of *Venus & Adonis*.

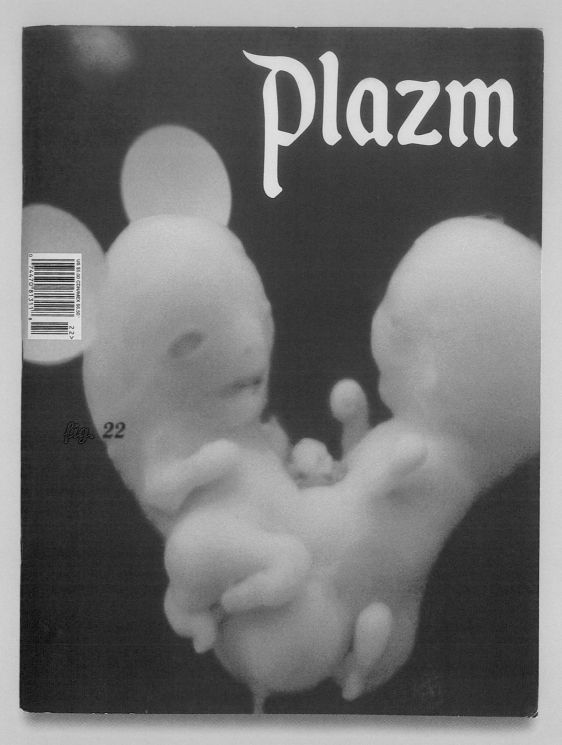

fig. 22

DESIGN COMPANY

Plazm

Babies normally bring out a "warm and fuzzy" feeling
in viewers. The dueling embryos on the cover of this
experimental arts publication, however, offer a whole
new outlook on "babes in (at) arms."

DESIGN COMPANY
Waters Design

While scientists might not be disturbed
by the topic of this exhibit's graphic
examples, the casual viewer likely will
have a totally different perspective.

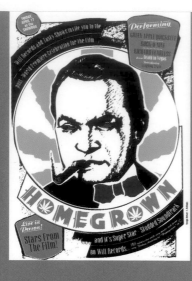

DESIGN COMPANY
Stewart A. Williams Design

Once again Stewart Williams demonstrates his design trademark through a comical treatment of incendiary topics.

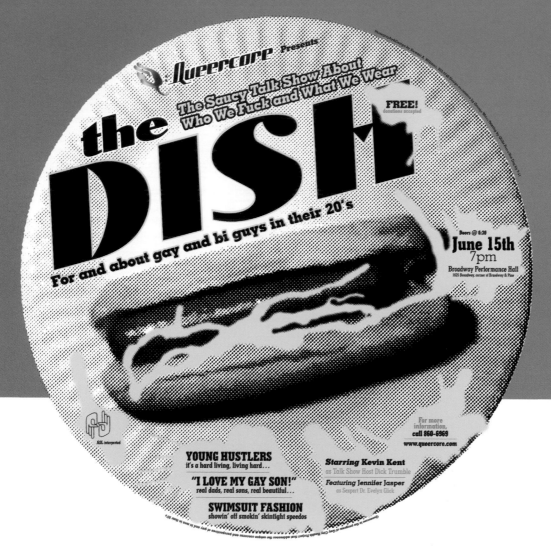

A Big

of
ECONOMY

IS NOTHING MORE THAN

Overture

The

<<< McCarthy: If one doesn't provoke oneself, others certainly
cannot be provoked by their actions, their messages. So why provoke
oneself? For challenge, for growth, for remaining vital, for
remaining curious, for continuing to ask stupid questions. >>>

ELEC TRIFYIN

chapter 5

/e-lek'-tru-fi-ing/ vt.
a: to give a shock of excitement to
b: thrill

They're emotion in motion, visual animators of an ordinarily stagnant world. They thrill us, inspire us, energize us, amuse us. **In short, they entertain.** It's not always easy to take a print project and turn it into something that makes people want to get up and move, yet some designers have a knack for bringing the static page—and its viewers—to life. How they accomplish their mission runs the gamut of visual and emotion-evoking machinations, from employing intense colors, cavorting typefaces, and images that explode with action, to arranging the elements in a manner that leads the eye about the page like a couple gliding across a dance floor. No matter the methodology, however, what all the work shares is that it is a tangible projection of its creator's spiritual dynamism. Just as you can always count on a Woody Allen movie to reflect his self doubt and dry humor, the designer's own kinetic spark likewise is revealed in his or her work. The results are, in essence, as much performance art as design. And they can be electrifying. Take Paul Sych's digital illustrations, for example. The vibrancy of the colors—his trademark—makes them jump off the page to invade the viewer's personal space (page 114). Contorted figures, voluptuous typefaces, and twisted shapes also impart an obviously digital, yet highly emotional vivacity to each of his creations. Sych's work also visually sings with rhythm, a factor that is a direct reflection of his musical alter ego. When Sych's design firm closes down for the night, you can often find him playing guitar with his jazz ensemble in a popular Toronto nightspot. It's only natural that this sense of creative improvisation is extended to Sych's visual orchestrations, too. Rafal Olbinski might use more traditional tools—he prefers the brush and canvas to the computer—but the results are equally invigorating (page 108). His surrealistic compositions have been called "an extraordinary testament to integrity, spirit, and adventure" by art critic Richard Burgin. Andre Parinaud, president of the Salon International De L'Affiche Et Des Arts De La Rue in Paris, notes that Olbinski "draws us into a different universe and forces us to use our eyes to participate in a marvelous world which is the true dimension of dreams." Today's clients and audiences are not the only beneficiaries of Sych, Olbinski, and their ilk. The world in general stands to gain from their innovative genius—one that has led to a genre of art in which the inert and animated merge for an electrifying aesthetic dynamism.

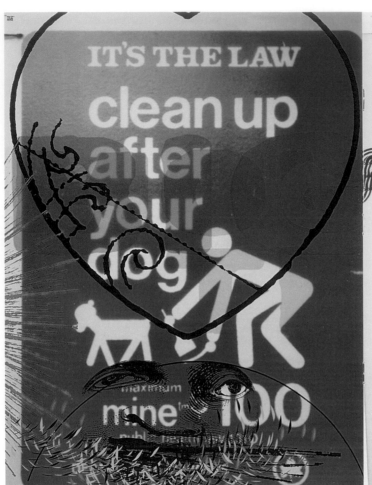
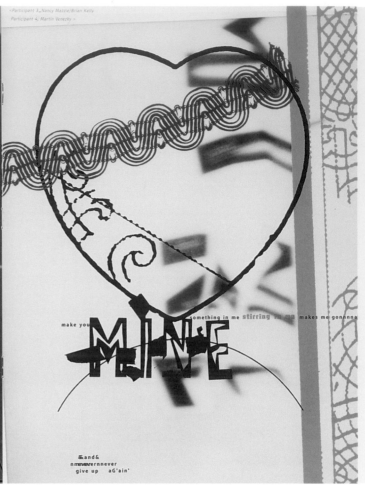

DESIGN COMPANIES
Plazm and guests

Nancy Mazzie and Brian Kelly (left) and Martin Venezky (right) responded with the images on this spread when Plazm challenged them and six other U.S.-based designers to participate in a "type as image" installation. Participants were asked to reconstruct, add to, subtract from, or otherwise modify a single design project that was circulated among them. The result, "Mine™," investigates the nature of ownership and collaboration in the digital age.

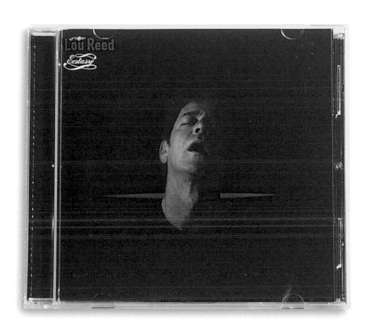

DESIGN COMPANY
Sagmeister Inc.

Lou Reed's own captivating facial
expression is all that is needed
to grab attention for his *Ecstasy*
CD packaging. As designer
Stefan Sagmeister succinctly
remarks, " '*Ecstasy*' was shot
while Lou was ecstatic."

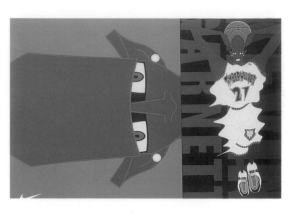

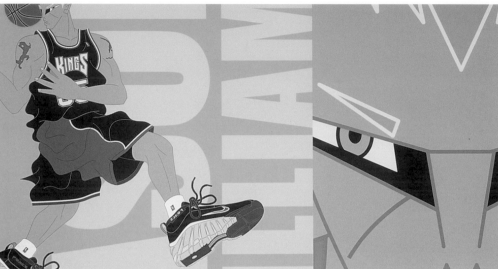

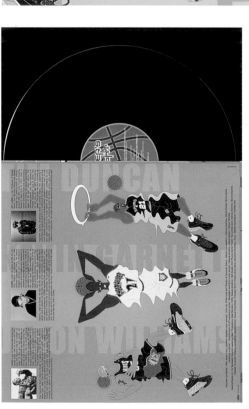

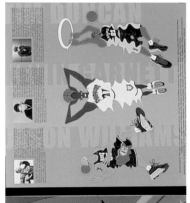

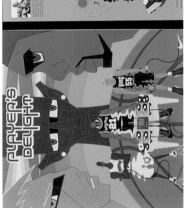

DESIGN COMPANY
Wieden Kennedy Tokyo

This highly recognizable illustration style is normally associated with Japanese superhero cartoons. John Jay used that style to give the sports figures on Nike's Players Delight ads and promotional LP packaging their own superhero status.

DESIGNER

Dan DeWitt

Designer Dan DeWitt's own scanned-in, highly
altered foot provides the intriguing centerpiece
of this proposed spread for a trend-analysis
report for Reebok International.

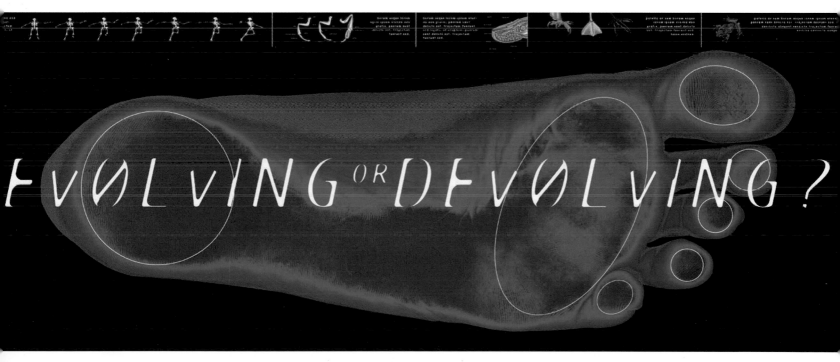

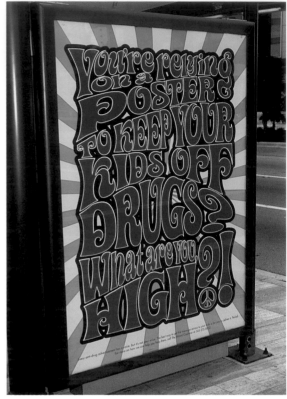

DESIGN COMPANIES
Modern Dog, Stoltze Design, and
Turkel Schwartz & Partners

Psychedelic colors, imagery, and
type associated with the 1960s and
'70s are employed in these modern-
day pieces to give each its own vital
impact. They are CD packaging by
Modern Dog (top left) and Stoltze
Design (bottom left) and a bus
shelter poster by Turkel Schwartz
(above) created for the Miami
Coalition for a Safe and Drug-free
Community/Partnership for a Drug-
free America. In the latter, the
graphics are designed to appeal to
today's parents who came of age in
the '60s, and hopefully compel them
to talk to their children about drugs.

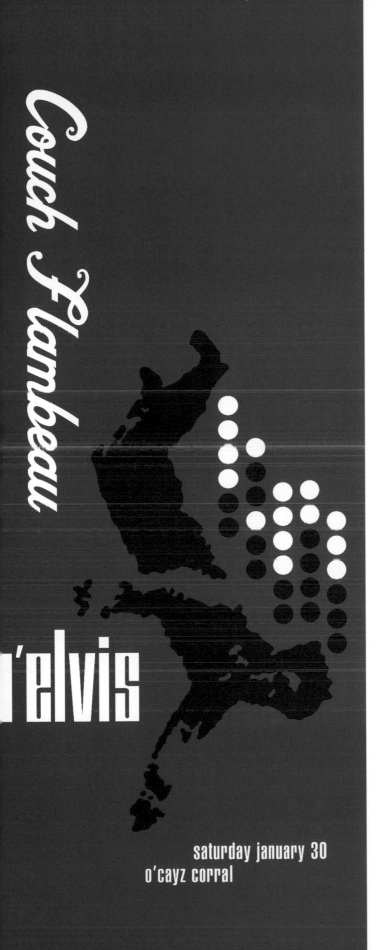

Couch Flambeau
'elvis

saturday january 30
o'cayz corral

DESIGN COMPANY
Planet Propaganda

"Couch Flambeau's" loud colors and silhouetted images are mindful of those used in the opening sequences to 1970s-era James Bond movies. Michael Byzewski created the poster in a series of posters for Purgatone Press that announced several local shows.

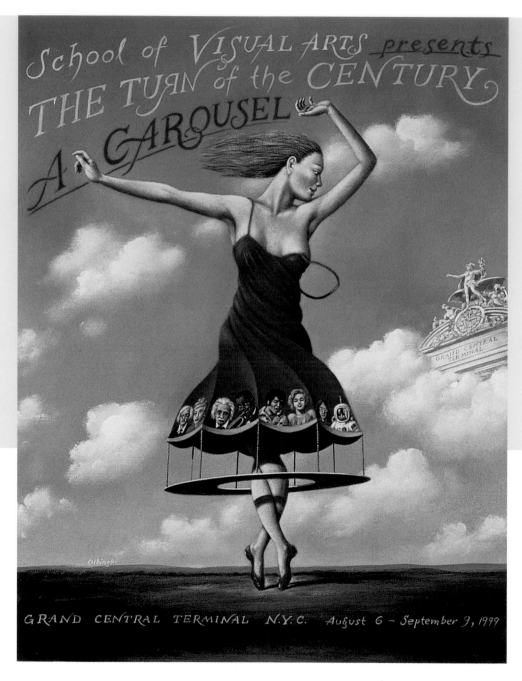

DESIGNER
Rafal Olbinski

Swirling skirts, flying straps, and entwined legs give Rafal Olbinski's dynamic dancer a sense of abandoned delight.

DESIGN COMPANY
titanium

This ad for the *Alternative Pick* source book is
reminiscent of the apparatus that came to life
in Disney's *Fantasia*. The instrument is actually
a nineteenth-century laboratory mechanism
consisting of two wooden eyeballs attached to
counterweights that was used to demonstrate
how the optic muscle works. Dann DeWitt was
playing with a photo of the image in Photoshop
when he accidentally pushed the wrong key. The
engaging illustration was the result.

wiredwire logo ©max kisman / max@maxkisman.com

DESIGNER
Max Kisman

The centipede-like logo that
Max Kisman created for a *Wired*
newsletter appears poised to
scurry across the page.

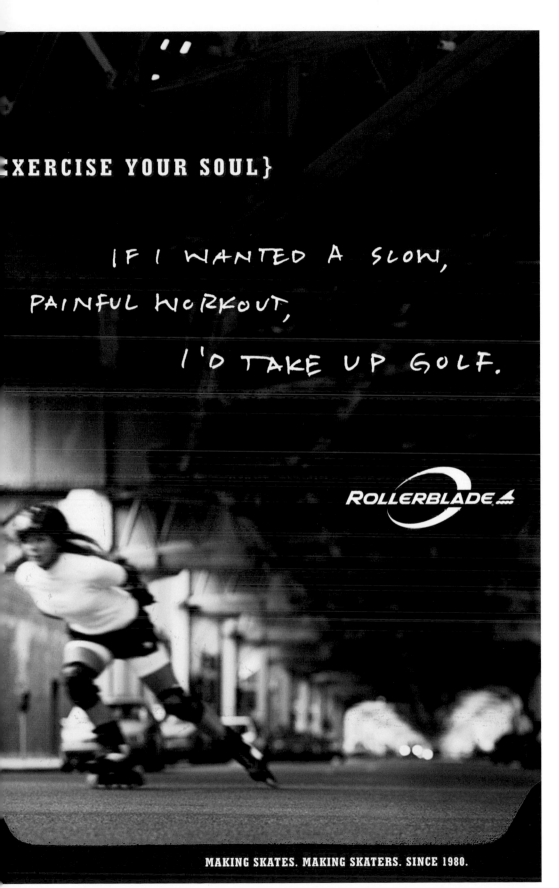

EXERCISE YOUR SOUL}

IF I WANTED A SLOW,
PAINFUL WORKOUT,
I'D TAKE UP GOLF.

ROLLERBLADE.

MAKING SKATES. MAKING SKATERS. SINCE 1980.

DESIGN COMPANY
Planet Propaganda

The design team wisely stands back
and lets the outstanding photog-
raphy by Steve Eliason make the
prime statement in this poster for
Rollerblade skates. The blurred
element gives the poster a strong
feeling of intense speed and action.

macromedia wwwhat? awards
what the web can be*design contest 2000

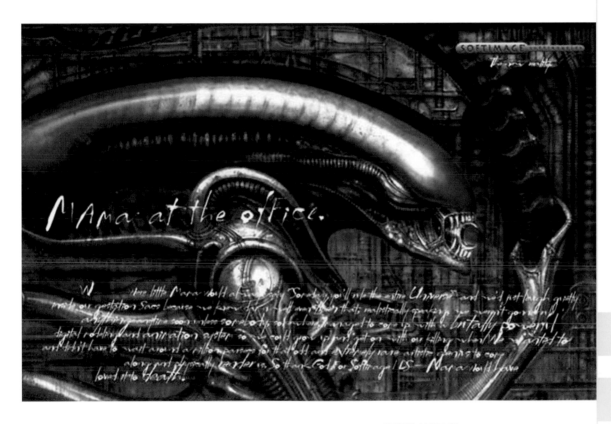

<<< McCarthy (cont.): I try to achieve a level of provocation, not through the graphic strategies of the visual design so much (that's too obvious and done so darn well by lots of people already), but rather by an engagement with the literal content. Words are not merely typeface choices, but ingredients in the stew of meaning available to designers. > > >

DESIGN COMPANY
titanium

The vicious, drooling character that H. R. Giger developed for the *Alien* film series is cleverly re-employed in this ad proposal, "Mama at the Office," created for a software/ hardware developer. Unlike *Alien* heroine Sigourney Weaver, however, "Mama" proved a bit too overpowering to the client who rejected the idea. (The image was taken from the cover of Giger's *Alien,* ©Morpheus International Publishing, Beverly Hills, California.)

OPPOSITE PAGE
DESIGNER
Victor Cheung

Victor Cheung's call-for-entries poster for a Web design competition uses bands of bright colors and glimpses of fast-moving vehicles to play off the idea of the information highway.

Paul Sych's digital illustration, "Limited Time Offer," presents an animated commentary on how the media, especially the Web, labels women. Sych uses his personal illustration work in his portfolio. So far, they have garnered assignments for him from several illustrious clients, including *Wired* magazine.

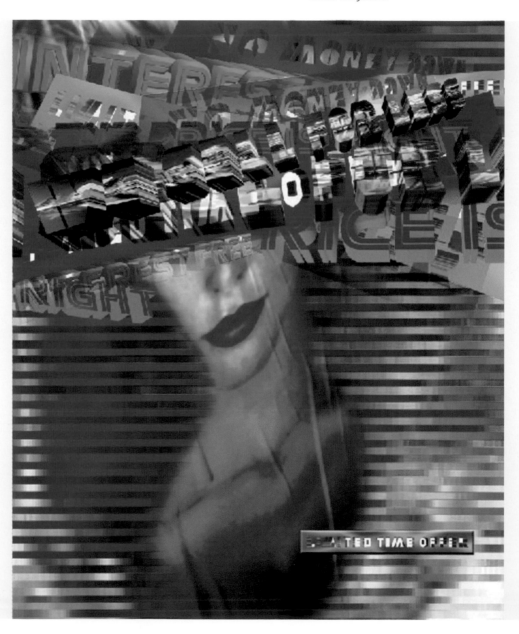

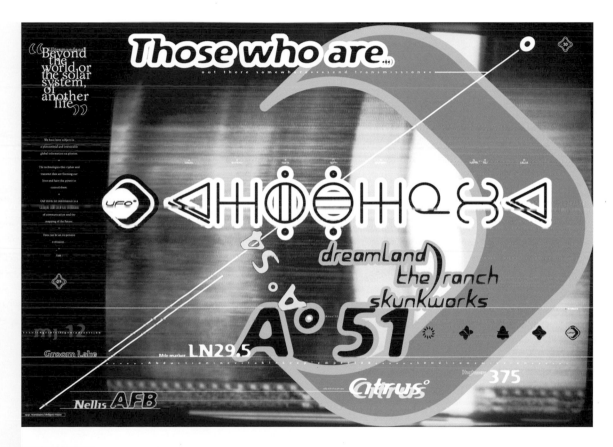

DESIGN COMPANY

Citrus

This spread from Citrus' self-promotion publication "Ex:haust Emission 2" deals with the power of information and what might exist in the unknown. The graphic symbols are derived from an "alien" language. The message translation is "those who are."

.COMPELLING

chapter 6

/kem pel' ing/: irresistibly or keenly interesting, attractive, etc.; captivating

Any editor of a design magazine can tell you that she is, literally, besieged with samples from those hoping to be featured in the publication. It doesn't take long for her to become immune to really good work. Only the truly outstanding or unusual piece will capture her attention. The average viewer is not all that much different. He must endure thousands of images being thrust in his face every day, so it's a rare project that can stop him in his tracks, compel him to remember it, and maybe even lure him back for another look. To achieve this state of design nirvana, the piece must be "irresistibly or keenly interesting or attractive," as the definition for compelling states. It's one thing to know where you want to be with your design project; it's another to know how to get there. The encouraging thing is that the only barrier to attaining your goal is lack of imagination. Take titanium's ad for a morphing program for video and filmmakers called Elastic Reality, for example (page 126). The product itself might cause some studios to go wild with morphing and then re-morphing images for the ad. Yet titanium approached it very simply—and effectively. The designers happened across two photographs of different types of objects that looked as if one had given birth to the other. So they just placed them side-by-side and added a short, but clever, line of copy. Then they let the viewer's imagination do the rest. Unfortunately, their approach was too simple for the client, who couldn't understand how you could convey the capabilities of a morphing program without actually showing them off. So the client rejected it. That's a pity. Anyone who sees titanium's ad proposal immediately gets it. Better still, the eerily identical photos of the car fin and the tree frog prompt viewers to return to it time and again to first puzzle out exactly what the images are and then to marvel at their similarities. And then they go on to wonder what they could achieve with this morphing program. It's the epitome of what a compelling work is all about. Even better, as titanium's ad along with many of the other studios' work seen in this section prove, neither tools, techniques, nor even budget seem to make a difference when it comes to creating a compelling design. While they can all help create a winner here is where the backbone of great design—the concept—truly takes center stage.

G ELLING

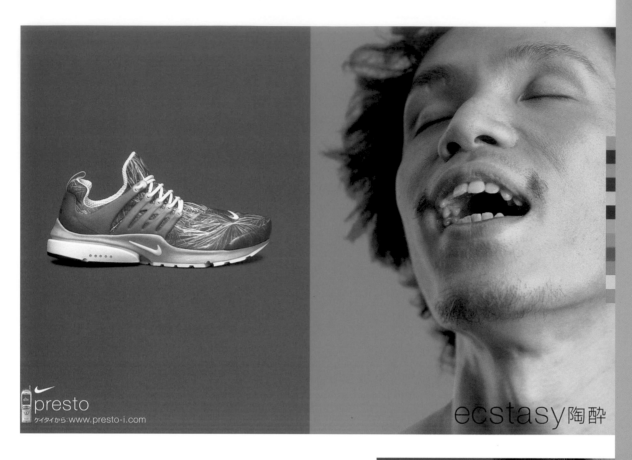

presto ケイタイから:www.presto-i.com

ecstasy陶酔

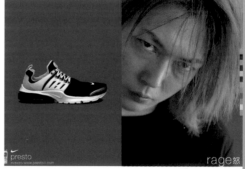

presto system.www.presto-i.com

rage怒

DESIGN COMPANY
Wieden Kennedy Tokyo

Eye-catching, highly expressive
portraits are the focus of a series
of ads for Nike footwear.

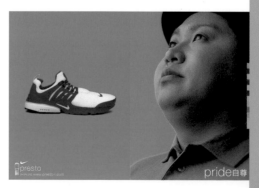

presto system.www.presto-i.com

pride自尊

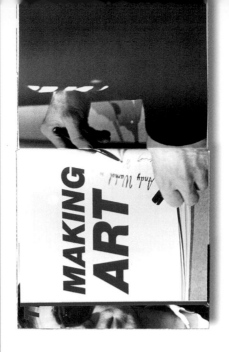

DESIGN COMPANY
Pentagram London

Angus Hyland's scrapbook approach to Andy Warhol's book, *Making Art*, aptly shows off Warhol's work while also giving viewers a very personal glimpse of the artist through its homemade sort of appeal.

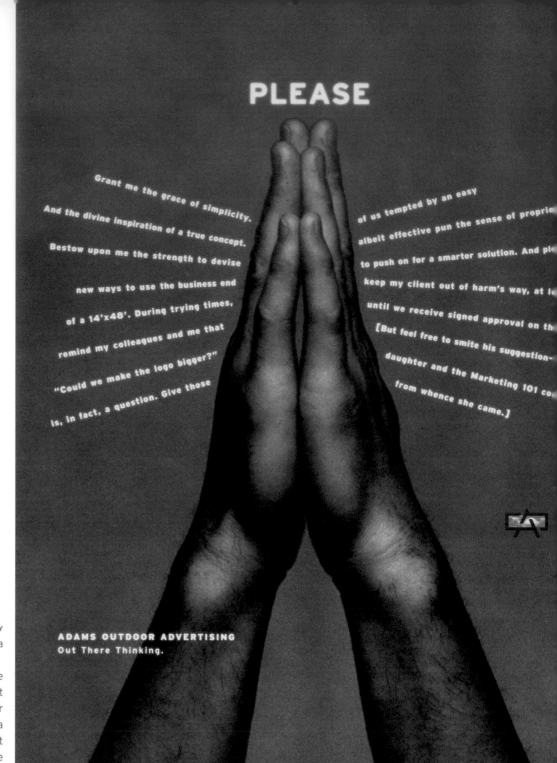

PLEASE

Grant me the grace of simplicity. And the divine inspiration of a true concept. Bestow upon me the strength to devise new ways to use the business end of a 14'x48'. During trying times, remind my colleagues and me that "Could we make the logo bigger?" is, in fact, a question. Give those of us tempted by an easy albeit effective pun the sense of proprie[ty] to push on for a smarter solution. And pl[ease] keep my client out of harm's way, at l[east] until we receive signed approval on th[e] [But feel free to smite his suggestion— daughter and the Marketing 101 co[urse] from whence she came.]

ADAMS OUTDOOR ADVERTISING
Out There Thinking.

DESIGN COMPANY
Planet Propaganda

At first glance, the message of this riveting photo must either be religious or a plea for charitable assistance—an idea furthered by the halo-like effect of the type surrounding the hands. Instead, viewers will find an irreverent prayer for a great concept (and client). The ad was created by Planet Propaganda for Adams Billboard.

<<< McCarthy (cont.): It's like how Warhol's Campbell's Soup picture has been accepted and commodified, while a bowl of actual alphabet soup allows for user interaction, kinetic, and temporal considerations, some biological value—it's a true performance art. >>>

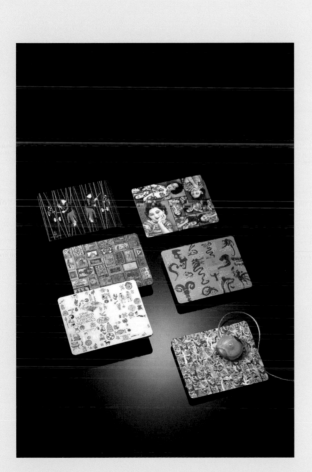

DESIGN COMPANY
Alan Chan Design

Alan Chan's aesthetic prowess
turns mouse pads into canvases
for works of art, resplendent
with rich colors, lush drawings,
and complex scenes.

101 BEST SHOW

101 – the basic elements of digital programming; from these digits spring images that transcend traditional artforms. From all the entries to the IdN awards, 101 outstanding pieces of digital art have been selected. The emphasis in selecting these awards was on creativity rather than technical ability; it is not what the computer is capable of that counts, but what the designer is capable of doing with the computer.

4TH BIENNIAL IdN DESIGN AWARDS 1999 → 2000

DESIGNER
Victor Cheung

An intriguing, old-fashioned portable television recalls the media's not-so-distant ancient history, while simultaneously grabbing viewers' attention in Victor Cheung's compelling ad. The ad announces a new media design competition.

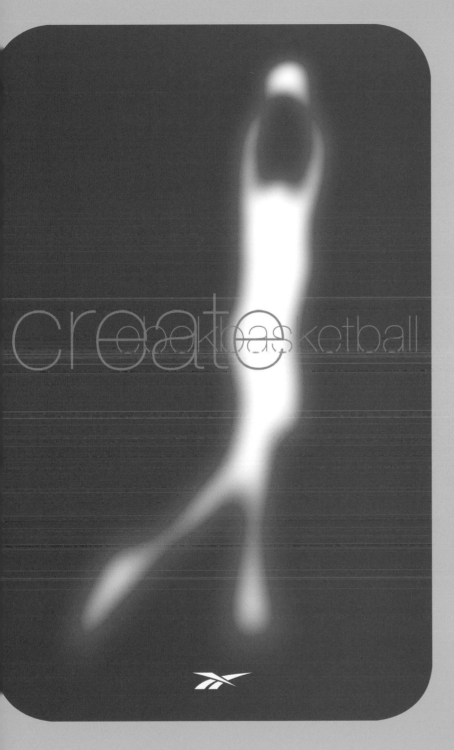

create basketball

invent basketball

DESIGN COMPANY
titanium

Ghostly figures take center stage
in these ad proposals that titanium
developed for Reebok. In the ads,
the studio wanted to project the
concept of the athlete's soul.
It accomplished this by taking
endorsement photographs from the
client's files and using Photoshop
to blur them beyond recognition.

The devil to pay
 The four of hearts
The origin of evil

3 NOVELS

BY ELLERY QUEEN

DESIGN COMPANY
Stewart A. Williams Design

Designers and movie buffs will
quickly recognize the influence
behind this book ad created by
Stewart Williams.

DESIGN COMPANY
Wang Xu & Associates

Designer Wang Xu plays off the
magazine's name, transforming one
image into another in this cover and
inside spreads for the "New Edition"
of Design Exchange.

DESIGN COMPANY
titanium

The product was Elastic Reality, a morphing and special-effects software. So titanium decided to inject some irony into its ads by using real, untouched images to convey the product's capabilities. On the left is a fender fin from a 1957 Thunderbird coupe. On the right is its "evil twin"–a poisonous tropical tree frog.

DESIGN COMPANY
Citrus

This card is one of a series of 12 designs for six double-sided, limited-edition cards created as part of Citrus' "Ex:haust Emission 2" self-promotion. The promotion dealt with the issue of information and power.

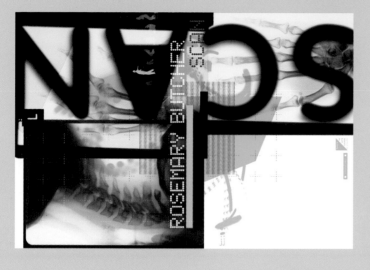

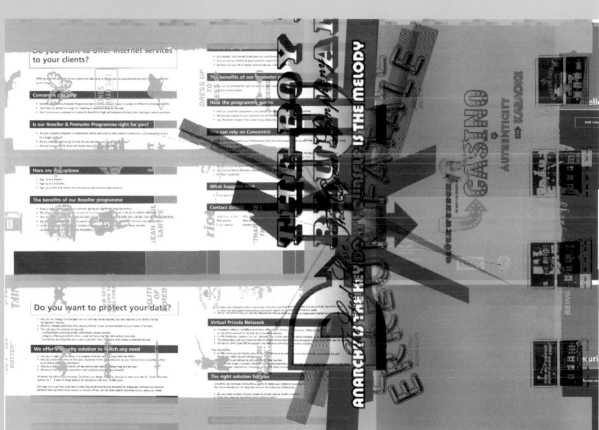

DESIGN COMPANY
Why Not Associates

Neon-like lettering, vivid colors, and
layers of multifaceted messages are
just a few of the signature ways in
which Why Not injects emotional
drama and excitement into its work.

<<< **Lann DeWitt / titanium:** It's like this totally unpredictable
drug that suddenly appears and drills its way into your skull when you
least expect it, but whose effect, ironically, is always to amplify
the fact of your own existence. It's wild, it's crazy, and hey, it's
totally legal here in the U.S.A. (at least for now). I say, "Let's get
us some more, quick." >>>

DESIGN COMPANY
Pentagram London

Angus Hyland's clean, unaffected
treatments bestow a visual
potency on his book designs.
Both were created for Canongate
Books Ltd.

SCAR CULTURE

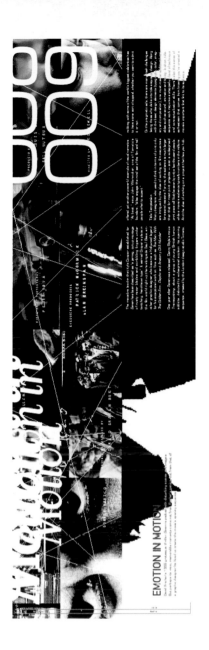

DESIGNER
Victor Cheung

Victor Cheung begins his layouts for *IdN* (above) and *Flips* magazines by collecting as many samples as possible from the featured artists. Then, rather than simply presenting the work gallery-style, he gives each work a whole new life of its own—one that also conveys the personality of its original creator.

EMOTION IN MOTION

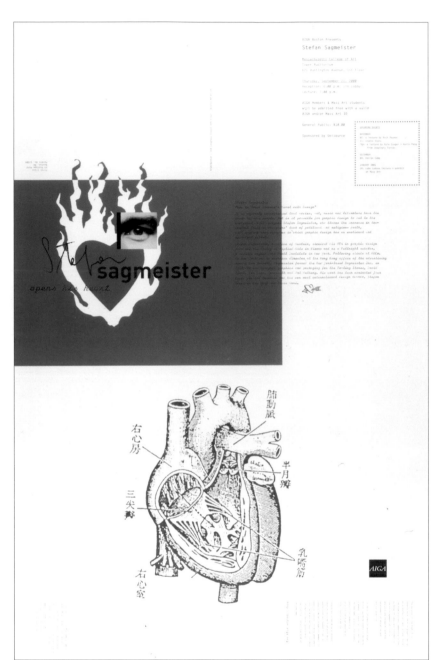

DESIGN COMPANY
Stoltze Design

A poster printed front and back for a Stefan Sagmeister lecture shows the nature of the presentation, as the designer examines his heart and soul and then shares what he discovers with the audience.

DESIGN COMPANY
Stewart A. Williams Design

The vibrant colors of the text situated against the illustration's subdued grays give this book cover a stunning impact.

DESIGN COMPANY
titanium

"Truth Tour 2000," an anti-smoking campaign that grew out of the tobacco settlement, is an example of true grassroots marketing. titanium designed everything from uniforms to videos to vehicle graphics for Truth's cross-country tour that targeted young people in key cities across the United States.

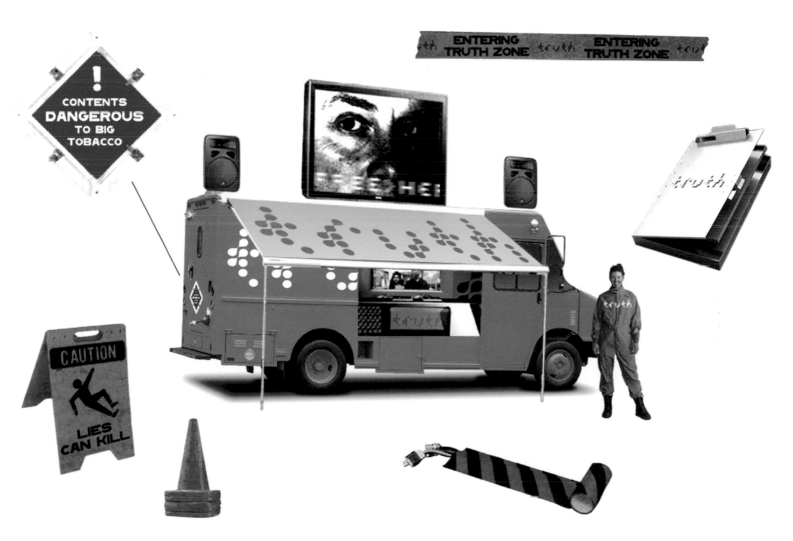

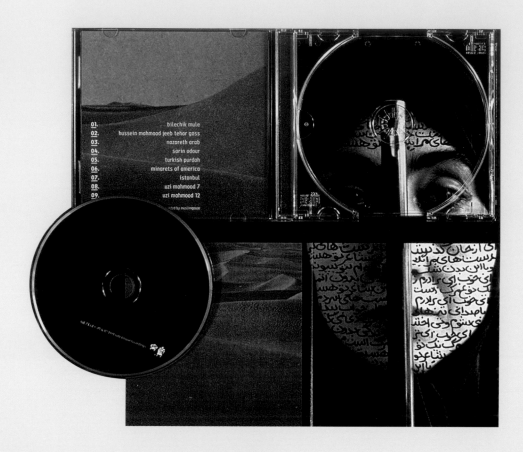

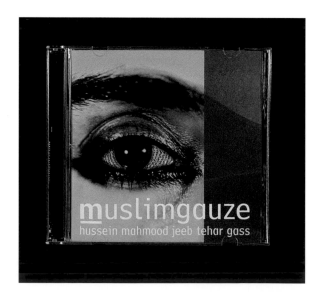

DESIGN COMPANY
Plazm

A CD cover and booklet for
Muslimgauze calls on the
musician's Middle Eastern
influences for its own
charismatic bearing.

DESIGN COMPANY
Pentagram London

The "Walk 2000" poster that
Angus Hyland developed literally
asks viewers to trod on it.

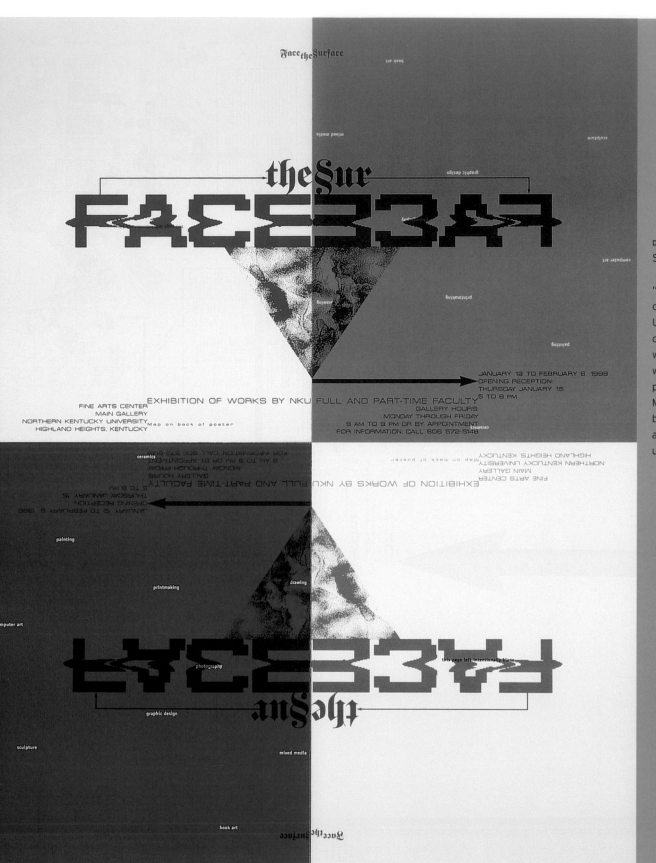

DESIGNER
Steven McCarthy

"Face the Surface," a poster created for Northern Kentucky University, was designed in one color, then the second was added when the poster was rotated 160 degrees on press. Designer Steven McCarthy says that this was both an economical solution and a way to create intrigue using image and type.

An art/music compilation

DESIGN COMPANY
Stoltze Design

A series of shocking, outrageous, and compelling images make up this poster used to promote the Anon CD at record stores and clubs. Overprinting the Anon script logo on the press sheet also led to a very economical design solution.

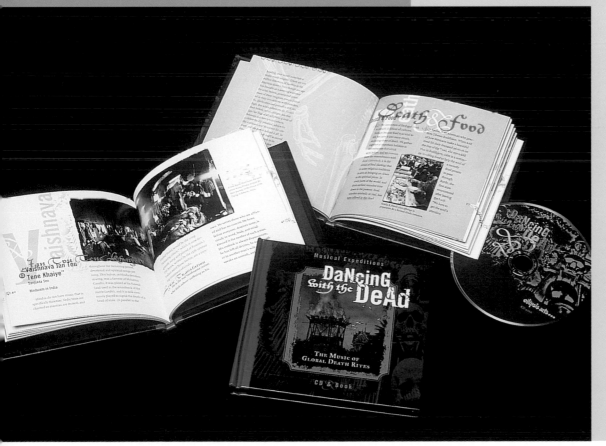

DESIGN COMPANY
Stoltze Design

Dancing with the Dead is a collection of death ritual music from around the world. The designers say that the sometimes celebratory, sometimes macabre recordings inspired their gothic design for the CD's cover and booklet.

CHALLENG

/chal'enj-ing/ **a:** to call to account
b: to demand proof or explanation

Think about it. That's what every designer in this section is attempting to make viewers do. Whether through visual elements, design treatment, personal commentary, or even the subject matter itself, they want us to stop, look, and consider—and then do it all over again and again. It doesn't end there, however. Next they want us to react—maybe by giving to the food bank or participating in a protest movement, or maybe just by arguing with them or someone (anyone) about their point of view. To effectively challenge an audience, the work must get under viewers' skin. It must stay with them even after they can no longer see the item—like the beautiful, but haunting eyes of the child in the Web site that Waters Design created for a food bank (page 143), or Plazm's crude but cogent Gulf War protest sticker (page 154). The work can operate on many levels, as do Alan Chan's "Mao" posters (page 142), or it can be a simple and straightforward statement, like Haley Johnson's commentary on how television has hurt literacy (page 157). It can be shocking, sweet, beautiful, ugly, and it can come in many forms. One of the best mediums via which to publish design projects aiming to challenge the audience is proving to be the Internet. Its interactive capabilities and the ease by which a site can be posted allow not just design professionals to disseminate provocative ideas, but the general population, too. In effect, anyone who can gain access to an online computer can tell the world what they think about anything and everything. The immediacy of the Internet is also a huge asset to those looking to tweak the social conscience. Design professor Steven McCarthy has an ongoing center of discussion, for example, at his Web site (www.home.earthlink.net/~seminal) where he can quickly post his views on current issues such as gun control or the disparity between the incomes of Apple's Steve Jobs and the regular apple picker. Viewers are also invited to share their opinions in this ultimate modern form of the old-fashioned Town Hall. **No matter what medium a challenging piece is presented in or how such a work is accomplished, to be successful it must serve as a catalyst for deliberation. And, hopefully, it will also serve as a catalyst for change. For, as any designer who strives to provoke the audience will tell you, the worst response would be no response at all.**

NG

LING

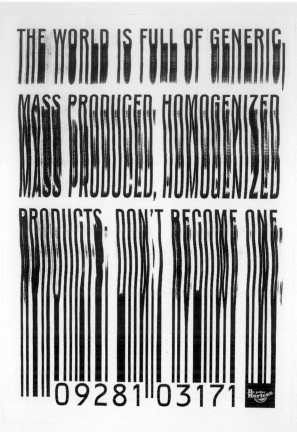

DESIGN COMPANY
Pyro Brand Development
CREATIVE DIRECTOR
Todd Tilford
WRITER
Todd Tilford
ART DIRECTOR
Eric Tilford
PHOTOGRAPHER
James Schwartz

A simple distortion turns this
mass-marketing icon into a symbol
of nonconformity.

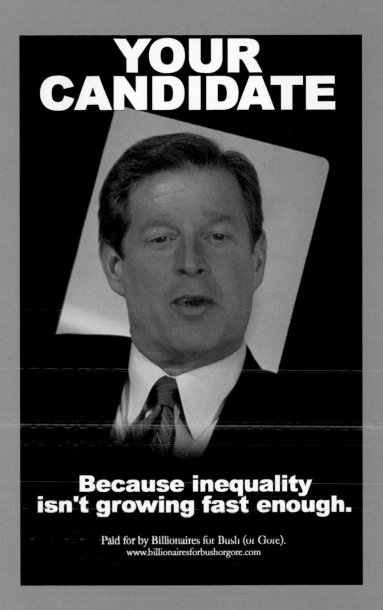

DESIGN COMPANY
Billionaires for Bush (or Gore)

The Billionaires for Bush (or Gore) satirical commentary on the sameness of the two major parties' candidates in the 2000 U.S. presidential election exhibited an uncanny prescience regarding the mindset of American voters. Weeks after the election was over, the results were still too close to call.

Q: How far can you go before you go too far?

<<< Johnson: There are so many niches of adults who (have the time! and) will respond when they are upset by content that touches on religion, sexuality, violence, and the like. But I don't think that means you have gone too far, because dialogue is good. When your content is harmful in some way without causing any positive effect (whatever that is), you've probably crossed the line. > > >

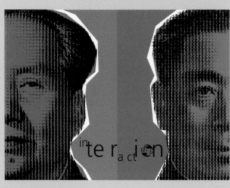

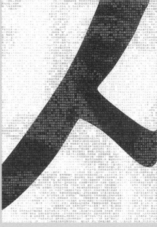

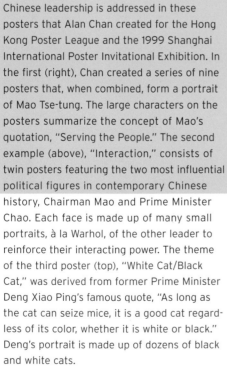

DESIGN COMPANY
Alan Chan Design

Chinese leadership is addressed in these posters that Alan Chan created for the Hong Kong Poster League and the 1999 Shanghai International Poster Invitational Exhibition. In the first (right), Chan created a series of nine posters that, when combined, form a portrait of Mao Tse-tung. The large characters on the posters summarize the concept of Mao's quotation, "Serving the People." The second example (above), "Interaction," consists of twin posters featuring the two most influential political figures in contemporary Chinese history, Chairman Mao and Prime Minister Chao. Each face is made up of many small portraits, à la Warhol, of the other leader to reinforce their interacting power. The theme of the third poster (top), "White Cat/Black Cat," was derived from former Prime Minister Deng Xiao Ping's famous quote, "As long as the cat can seize mice, it is a good cat regardless of its color, whether it is white or black." Deng's portrait is made up of dozens of black and white cats.

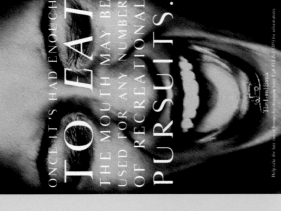

When the local food bank asked titanium
to help, partner Dann DeWitt responded
first with an entire branding campaign,
then with this atypical ad that rather than
dwelling on hunger's ill effects, empha-
sizes the happiness and well-being that
can come from good nutrition. Although
the client rejected the idea because it felt
people "wouldn't get it," a tamed-down
version for billboards met with success.

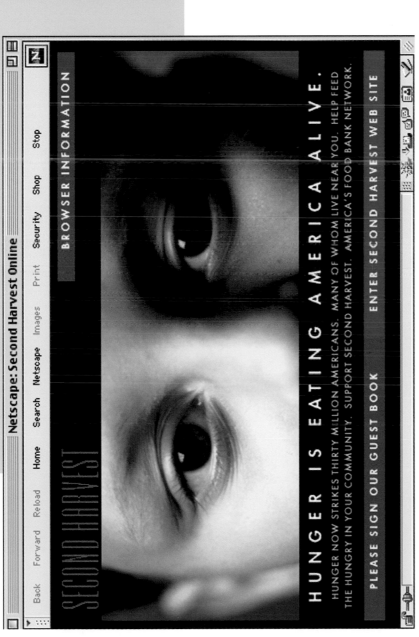

Waters Design takes a more tradi-
tional approach than titanium to the
subject of hunger, but the results
are equally challenging.

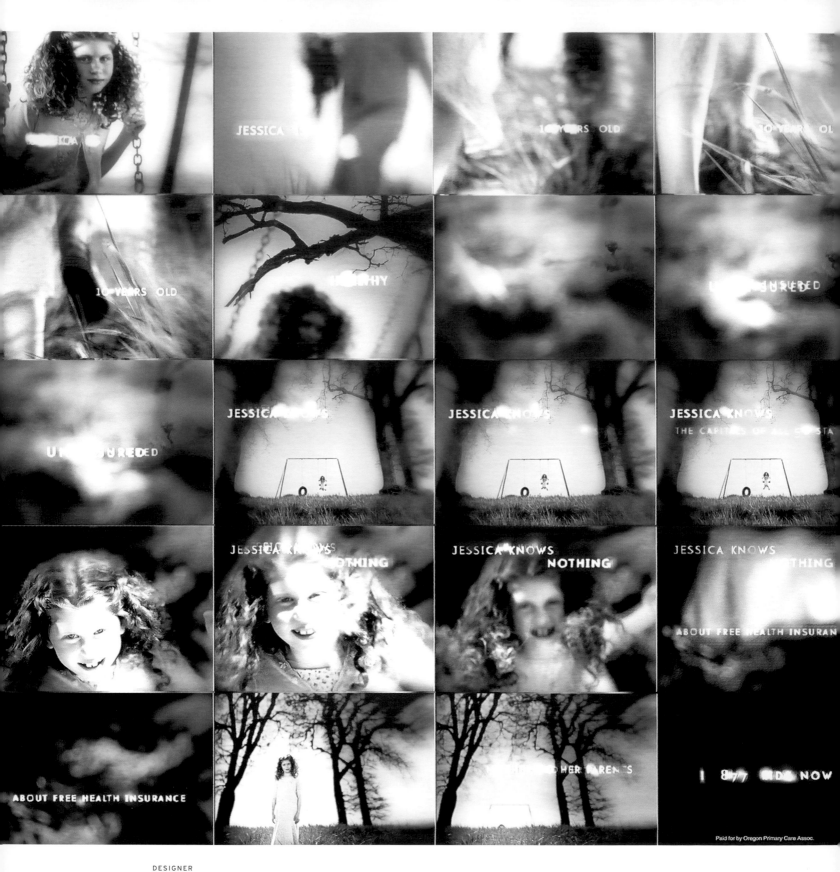

Paid for by Oregon Primary Care Assoc.

DESIGNER
Scott Clum

This compelling television commercial, "Jessica,"
directed by Jeff Mishler, deals with the importance
of good health coverage to a child's well-being by
using the little girl's innocence to stir viewers. Scott
Clum's typography appears and disappers through-
out the ad, further adding to its intrigue.

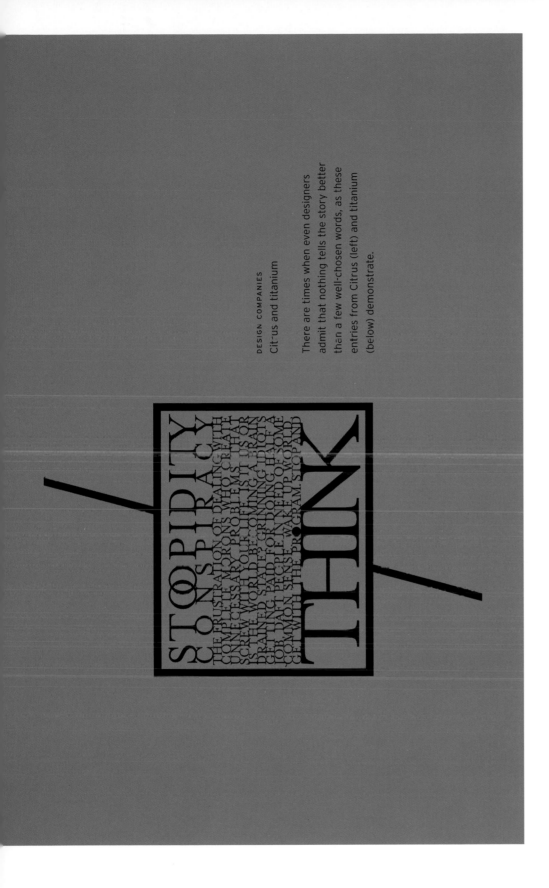

DESIGN COMPANIES
Cit-us and titanium

There are times when even designers admit that nothing tells the story better than a few well-chosen words, as these entries from Citrus (left) and titanium (below) demonstrate.

America 1999. Land of the free and home of the millions of responsible adults who still have to lower the shades and hide inside their own homes to smoke a joint.

www.norml.org

DESIGNER
Rafal Olbinski

Pointing out the visual similarities between two contradictory symbols makes Rafal Olbinski's peace poster particularly poignant.

DESIGNER
Max Kisman

Many say that the Internet is opening up the world. Others charge that it is only widening the gap between the haves and the have-nots. Max Kisman's poster for *Wired* magazine, paired with Brian Eno's stirring quote, makes a very powerful statement for the latter theory.

OPPOSITE PAGE
DESIGN COMPANY
Why Not Associates

The designers paired a happy, attractive couple and the beauty of nature with the highly recognizable typeface used for the title in the ominous movie Apocalyse Now. The poster announces an exhibition at London's Royal Academy of Art.

The prOBleM wIth cOMPutErS iS thAt theRe IS nOT eNouGh AfriCA iN THeM

ROYAL ACADEMY OF ARTS
PICCADILLY W1

APOCALYPSE

BEAUTY AND HORROR IN CONTEMPORARY ART

23 SEPTEMBER–15 DECEMBER 2000 DAILY 10am–6pm FRIDAYS UNTIL 8.30pm www.royalacademy.org.uk

Sponsored by
eyestorm
www.eyestorm.com

In association with
Time Out

THE INDEPENDENT
THE INDEPENDENT
ON SUNDAY

<<< Citrus: Again, different people react in different ways to particular types of stimuli. These reactions are often unconsciously "programmed" by an individual's history, general upbringing, education, or maybe a specific series of events within that person's life that the stimulant has triggered. >>>

DESIGN COMPANY
Faith

This digital illustration was created using a Photoshop filter and a scanned-in, crumpled-up flyer that designer Paul Sych found on the sidewalk outside his studio. When he began playing around on the computer with the image, he thought it looked like a face and took it from there. "Fat Man," a personal commentary on over-eating, was the result.

DESIGNER
Steven McCarthy

Voxelations: Her Voice is an interactive CD pairing anecdotes from the personal history of the designer's mother with images of women from reality and the media. After one public showing of the CD, McCarthy was told that it was provocative of him as a male to think he could adequately address women's issues. He responded by pointing out that he has a mother, wife, sisters, and a daughter, so he feels well qualified.

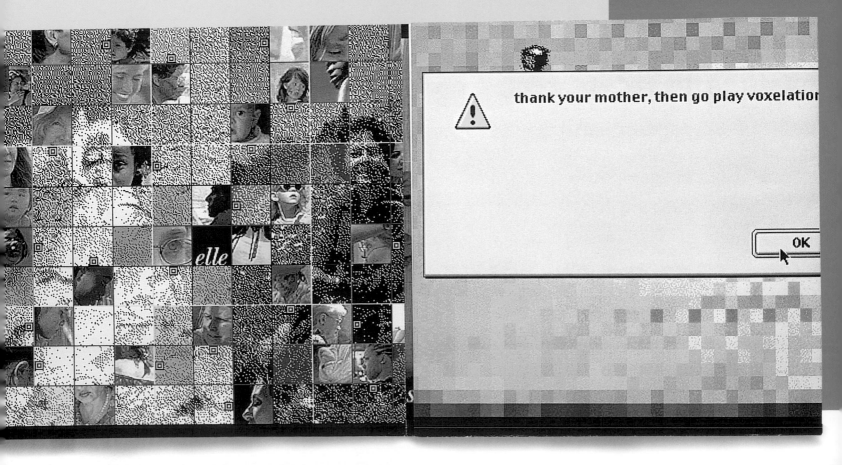

thank your mother, then go play voxelation

OK

Poster Love

Karel Míšek Karl Pilppo James Victore
Galerie Fronta 11.4. – 30.4. 2000 Spalená ul. 53 Praha 1

DESIGNER
James Victore

James Victore's often ludicrous, always challenging poster illustrations and concepts earn him the title "maestro of provocation" on a worldwide basis. The skull poster (above) announces an exhibition of his work in Prague, the "Less Is More" book cover playfully ridicules the title's concept, while his "Images of an Ideal Nation" poster puts the old political promise of "a chicken in every pot" to skinny shame.

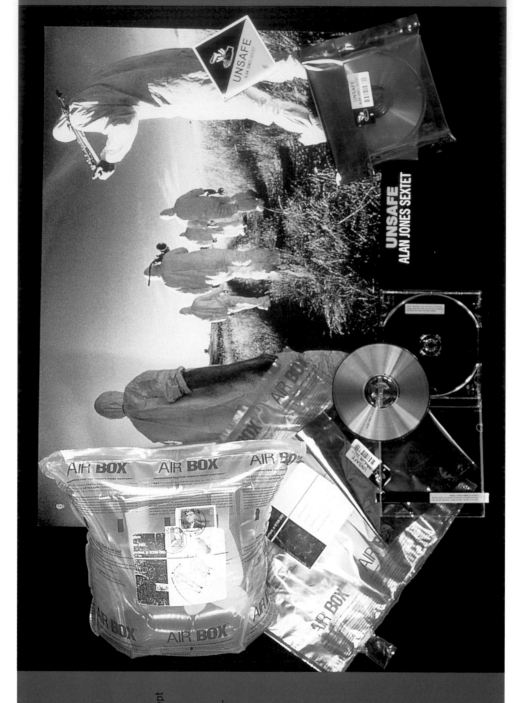

DESIGN COMPANY
Plazm

Packaging and promotions, including warning labels, safety materials, and even the band's haz-mat suits, extend the concept of *Unsafe*, the CD's title. The packaging delivers a secondary message, too, by challenging viewers to consider the environment's well-being.

DESIGN COMPANY
Pentagram London

"Tear Me Up" is a promotional poster that Pentagram London partner Angus Hyland produced for the British design publication *Creative Review*. It literally encourages recipients to tear it up.

<<< Citrus (cont.): In the same way that cognitive interaction puts shared experiences as a bond and trust mechanism between virtual strangers, so can provocative art/design—again depending on the desired outcome. All advertising is specifically aimed to draw a reaction—usually "buy me." Art, on the other hand, has a generally different outcome objective. As long as a piece makes people look, think, and/or consider, it will generally have succeeded in its role. "Buy me" is an added bonus. >>>

DESIGNER
Max Kisman

This poster for an AIGA
exhibition on new icons
utilizes its own challenging
new symbol to address the
issue of tunnel vision in
the creative world.

limited view - tunnel vision

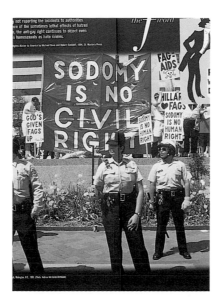

DESIGN COMPANY
The Pushpin Group

Pushpin Studio was formed in the mid-1950s to challenge the prevailing order of both design and society, a mission the group has never abandoned over the ensuing decades. The group's latest tweaking of the social conscious is provided by its publication *Nose*. *Nose* tackles all sorts of inflammatory issues through insightful articles and photographs by contributors and members of the studio, and especially through the thought-provoking illustrations of Seymour Chwast, one of Pushpin's original founders. D.K. Holland is the publication's editor.

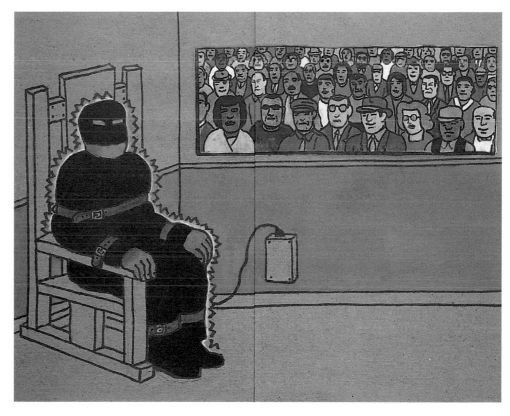

DESIGN COMPANY
Plazm

Former President George H.W. Bush's hawkish stance that led to the Persian Gulf War is the subject of this political sticker created by Plazm. The sticker was given away at protest events and "guerilla posted" on the street over newspaper boxes and traffic signs and at gas stations.

DESIGN COMPANY
titanium

A German software developer created a game about what might have occurred if events in U.S. history had gone differently. titanium partner Dann DeWitt's proposed packaging, then, challenges us to ponder the ramifications if Abraham Lincoln had been a slave rather than the president. The packaging was rejected after being shown to a focus group made up of Germans–an odd choice considering that the product was intended for the American market.

OFFICIAL DOKTOR BECKER SIMWARE

AMERICA

HISTORY IS BORING—UNTIL YOU START CHANGING I

WE HAVE BEEN SUBJECT TO
A PHENOMENAL AND IRREVOCABLE
GLOBAL INFORMATION EX:PLOSION.

○

THE TECHNOLOGIES THAT CIPHER AND
TRANSMIT DATA ARE FORMING OUR
LIVES AND HAVE THE POWER TO
CONTROL THEM.

○

OUR THIRST FOR INFORMATION IS A
CATALYST THAT FUELS THE EVOLUTION
OF COMMUNICATION AND THE
MAPPING OF THE FUTURE.

○

DATA CAN BE AN EX:PENSIVE
E-MISSION...

○

Trus°t

DESIGN COMPANY
Citrus

There are times when even designers
admit that nothing tells the story
better than a few well-chosen words.

<< Citrus (cont.): Only if a piece of work glorifies a particular taboo subject to such an extent that it has a physical effect on the people who have seen it and their reaction is to commit (sexual) violence, abuse, or murder, then under these circumstances we think everybody would agree that it had gone too far. This scenario however is extremely unlikely, given the sheer dominance of other mass media methods of stimuli. >>>

don't vote

drink

have sex

work

move along

DESIGN COMPANY
52mm

"Move Along" is 52mm partner Damion Clayton's sarcastic commentary on the overindulgence and consequent lethargy of some young adults. The piece is part of the designer's personal collection that he also uses for inspiration.

DESIGN COMPANY
Faith

Paul Sych merged images of talk show and political icons Jay Leno, David Letterman, Bill Clinton, Mikhail Gorbachev, and Jerry Springer to create this satirical view of television in general. In the bottom corner he added a glowing Barney to designate the purple blob's reign as god of all TV characters. Sych uses the illustration for self-promotion purposes.

There is a site on the Internet containing a lesson plan for preschoolers intended to teach them all about the sense of touch. It begins by having the teachers collect a variety of textured materials, such as cotton balls, velvet scraps, aluminum foil, sandpaper, burlap, and dried leaves. It then instructs them to sit down with a small group of children, set the textured items out on a low table, and encourage the youngsters to feel each item and discuss what their hands and fingers tell them about it. Some designers consistently offer their audiences this same kind of sensuous encounter. They create projects that are so tangibly appealing that they, too, could serve as the textured examples in a classroom learning experience. The work goes beyond merely being tactile, however, it comes alive before your eyes. It entices you to reach out and touch it, taste it, smell it, examine it, experience it. You can not only see each piece's organic essence, but physically absorb it, too. As often as not, the work that holds this sort of tangible attraction today has been produced digitally. In the computer's early days, many designers loathed it for robbing their profession of its tactility. And they were right to be concerned. Their technologically hypnotized peers went wild with layering, distorting, merging, blurring, bastardizing, and all the other tricks the new toys allowed. Blinded by all this gimmickry, they nearly forgot one of design's most alluring aspects—its sensorial side, something that was previously relayed through such graphic vehicles as beautifully kerned type, exquisite fibered papers, letter-pressed pages, and rich, earthy hues. Thankfully, the era of digital swill is mostly behind us now. As designers have finally become comfortable with the computer, they also have become more adept at using it and the software it has spawned. Just as important, they have become better judges as to what it is good at doing and what it isn't. Take a look at Scott Clum's work to see how sensuous a computer-produced piece can be (page 161). Just as the Internet site instructed teachers to begin their lessons by collecting an assortment of textured materials, the genesis of Clum's art is often close-up photos of natural elements that he shoots and then keeps in his files. When the time comes, Clum scans the photos into the computer and then, much like Dr. Frankenstein, picks interesting parts from each and assembles a whole new "organism." Unlike the misguided doctor's monster, however, Clum's work exhibits a spirit and beauty that comes from softly glowing pastels, gently blended edges, willowy shapes, and other such masterful manipulations. His work doesn't just tantalize the physical senses; it also creates a sense of intrigue, as viewers puzzle over how each image was built. Clum and others like him have, thankfully, reached back into the past to retrieve design's better qualities. Then, by factoring in the computer's own unique artistic capabilities, they have taken their work to a whole new level of sensuous appeal.

DESIGNER

Victor Cheung

The distressed "metal ridges" that
Victor Cheung created for a *Flips*
magazine ad leave viewers itching to
run their fingers across them. If they
were able to do so, however, they
might be surprised to learn that the
"metal" is actually bubble wrap.

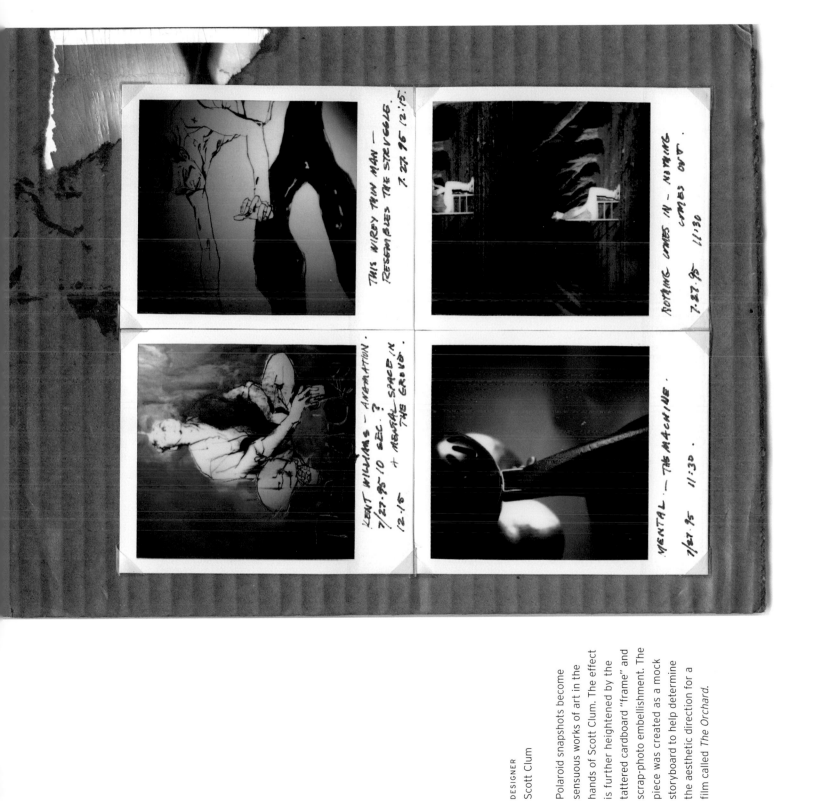

THIS WIREY THIN MAN —
RESEMBLES THE STRUGGLE.
7.27.95 12:15

NOTHING COMES IN — NOTHING
COMES OUT.
7.27.95 11:30

KENT WILLIAMS — ANIMATION.
7/27.95 10 SEC. ?
+ MENTAL SPACE IN
12:15 THIS GROUP.

MENTAL — THE MACHINE.
7/27.95 11:30.

DESIGNER
Scott Clum

Polaroid snapshots become
sensuous works of art in the
hands of Scott Clum. The effect
is further heightened by the
tattered cardboard "frame" and
scrap-photo embellishment. The
piece was created as a mock
storyboard to help determine
the aesthetic direction for a
film called *The Orchard.*

DESIGN COMPANY
Planet Propaganda

The theme for the 2000 edition of the *Alternative Pick* sourcebook (which targets the music industry) was "spirit." This led Planet's designers to question what drives creatives to do what they do, an issue they addressed through a series of pages featuring natural and organic elements.

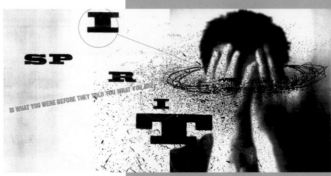

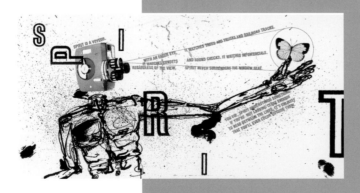

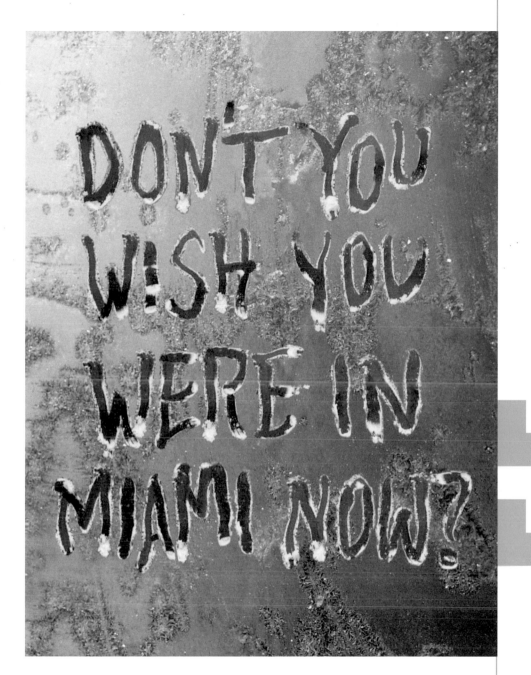

DESIGN COMPANY
Turkel Schwartz & Partners

A message traced by a finger
along an icy window brings chills
to viewers of this poster, although
in reality the "ice" is an electrostatic
material. The poster was done for
the Greater Miami Convention and
Visitors Bureau.

DESIGN COMPANY
Wang Xu & Associates

Wang Xu relied on the ancient art of Chinese calligraphy to illustrate the expressive qualities of Lu Sheng Zhong's book *Artistic Composition Writing*. The posters were created for the China Youth Press.

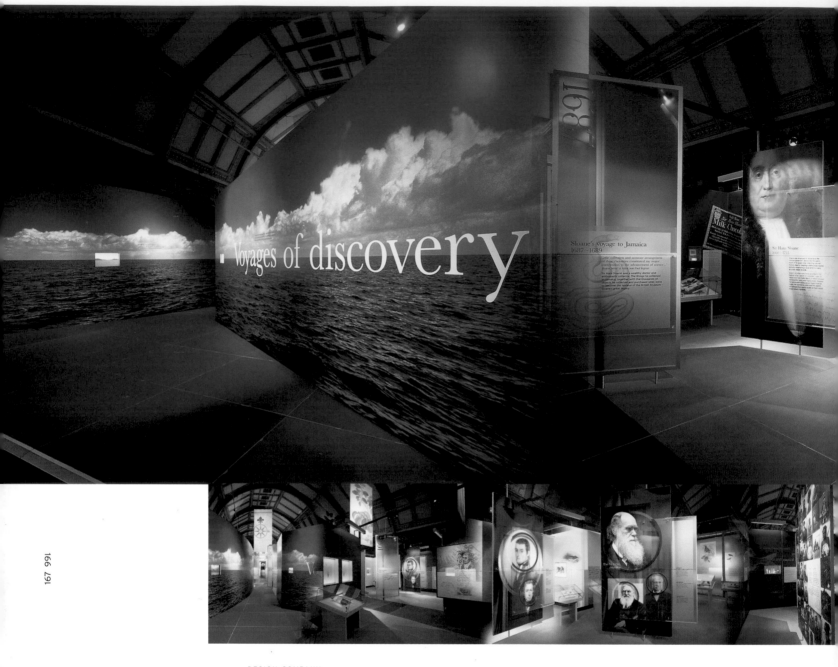

DESIGN COMPANY
Why Not Associates

Why Not's graphics for the London
Natural History Museum's "Voyage
of Discovery" exhibit offers more
than a trip through Britain's seafaring
history. It's a lavish visual journey,
offering visitors a sense of actualy
being there.

DESIGNER
Scott Clum

Electrifying colors make these
"celestial bodies" that Scott Clum
created for his portfolio appear to
pulsate with energy. Clum created
the image while experimenting with
light. He began in Freehand using
a model of a 3D vector shape, then
built upon that in Photoshop.

titanium

This odd figure's "squeezably" voluptuous
contours make it somehow sensuous, too.
The card's shape follows the figure's bulges,
intensifying the sensory effect. It announces
titanium's first foray into type design with a
face called "Bastardville." On the back of the
card are apologies to John Baskerville.

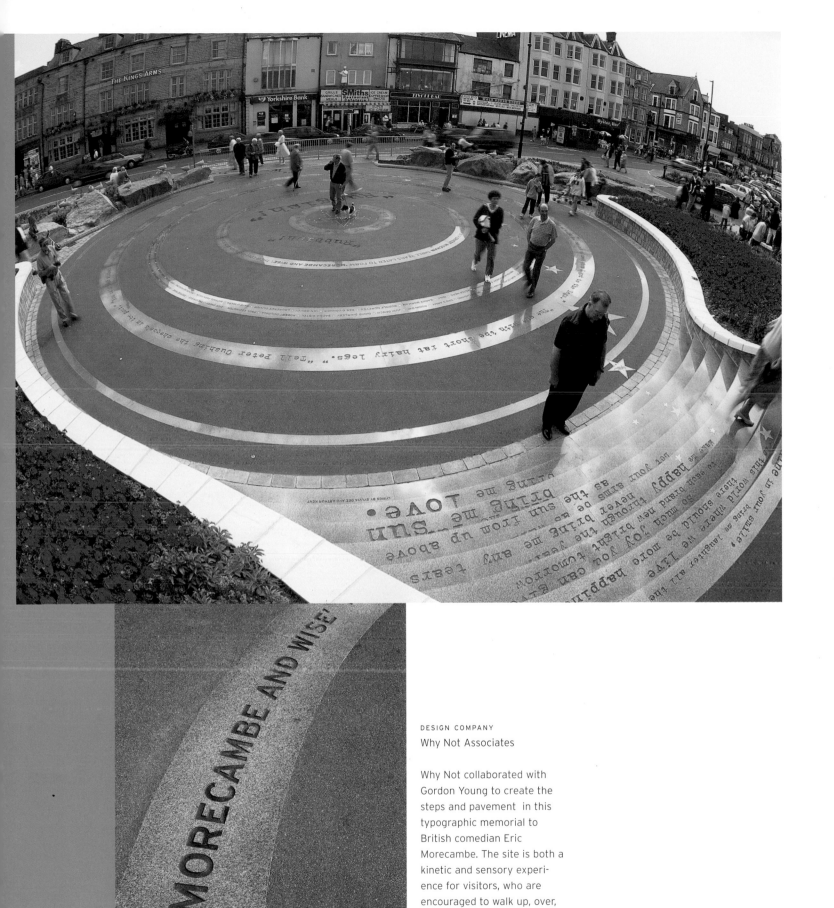

DESIGN COMPANY
Why Not Associates

Why Not collaborated with
Gordon Young to create the
steps and pavement in this
typographic memorial to
British comedian Eric
Morecambe. The site is both a
kinetic and sensory experi-
ence for visitors, who are
encouraged to walk up, over,
and all around the memorial
located in Lancaster, England.

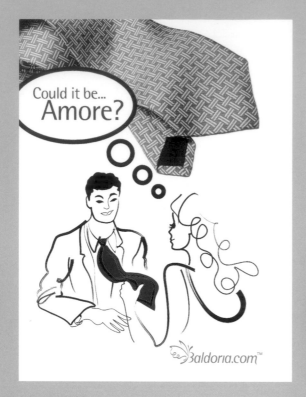

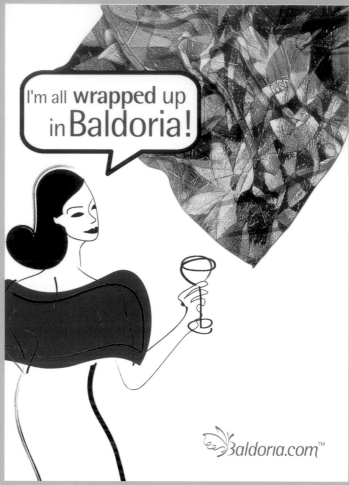

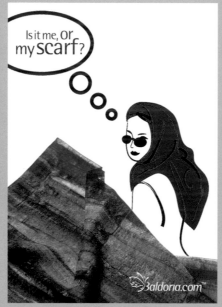

DESIGN COMPANY
Waters Design

Soft, silky sophistication, bright colors, and a bold, illustrative style often associated with fashion design effectively promote Baldoria's Internet site in a series of print ads by Waters Design.

DESIGN COMPANY
Sagmeister Inc.

A brochure that Stefan Sagmeister and Hjalti Karlsson developed for fashion designer Anni Kuan had a peculiar inspiration: laundromats. The brochure actually fulfills the criteria for several sections in this book, but its overwhelming sensuality resulting from the street-graffiti type treatment, earthy hues, Martin Woodtli's organic illustrations, and hefty cardboard covering solidly place the brochure within the category of "sensuous."

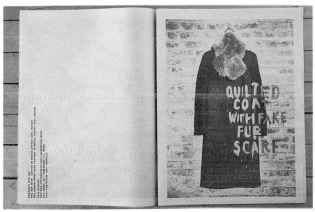

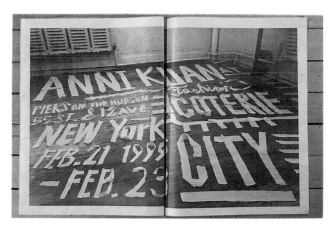

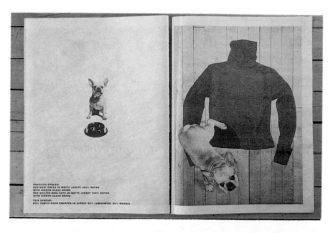

A CROSSOVER OF A RT TO DESIGN

DESIGN COMPANY
Wang Xu & Associates

A ragged border and the letters'
running edges—a result of ink
spreading into the paper's fibers
—make "Ink Painting and Metropolis"
a rich palpable experience. Wang Xu
designed the poster for the Second
International Ink Painting Biennial
of Shenzhen 2000.

<<< McCarthy (cont.): Would I share this with my children? I don't ever want to say: "Do as I say, not as I do." Furthermore, it's sort of like Charles Eames' penchant for varying scale when analyzing a design problem, asking the opinions of children.

They're the provocateurs of tomorrow, and the latent audience of today. >>>

SUN+MOON
A CONTEMPORARY DELI

DESIGN COMPANY
Segura Inc.

Carlos Segura keeps this logo simple, clean, and, consequently, sumptuous.

OPPOSITE PAGE
DESIGN COMPANY
Gable Design

Moody colors and an expressive central figure lend an air of mystery and sensuality to this poster announcing a Seattle theater group's production of Tennessee Williams' *Glass Menagerie*.

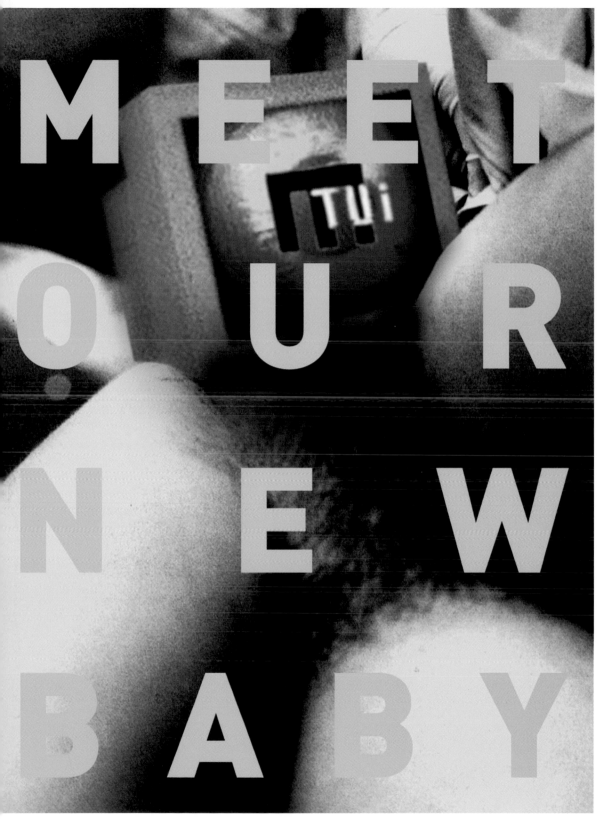

MEET OUR NEW BABY

DESIGN COMPANY
titanium

titanium's designers wanted to get up close and
personal to announce the client's latest project.
The client, however, threw them out of the deliv-
ery room (that is, it rejected their ad proposal).

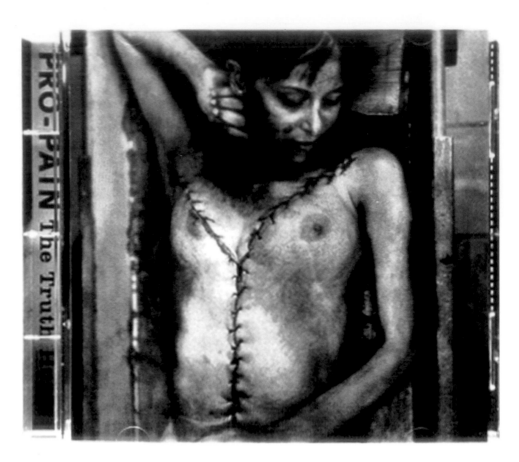

DESIGN COMPANY
Sagmeister Inc.

"Pro Pain"

I won't deny that studio's right to decline. That's what freedom of choice is all about. But what disturbed me was that the studio's staff had attended a design conference shortly before my invitation where Sagmeister and Valicenti explained why they did what they did regarding the objectionable projects. During his session, Sagmeister even said that if given the opportunity to do it over, he would not use the deceased woman's image on the CD—although there might be other projects where it would be appropriate. Sagmeister and Valicenti's thought-provoking presentations stirred up an intense discussion, one that continued long after we all had gone home. No matter how you felt about it, their work had proven its value because it caused us to question our own creative incentives and judgments and, most importantly, the consequences that can result. When I asked the studio what they thought about this, I received a blank stare. They had not bothered going to either presentation, instead, they went shopping. Therein lies the crux of the censorship problem. It's one thing to not have access to information; it's another to willfully ignore it. Too often, those who favor strict regulations governing what's acceptable and what's not do so because they won't take the time to learn the intent of the offending piece. And they certainly aren't open to considering whether in fact, like it or not, it might just be serving a useful purpose.

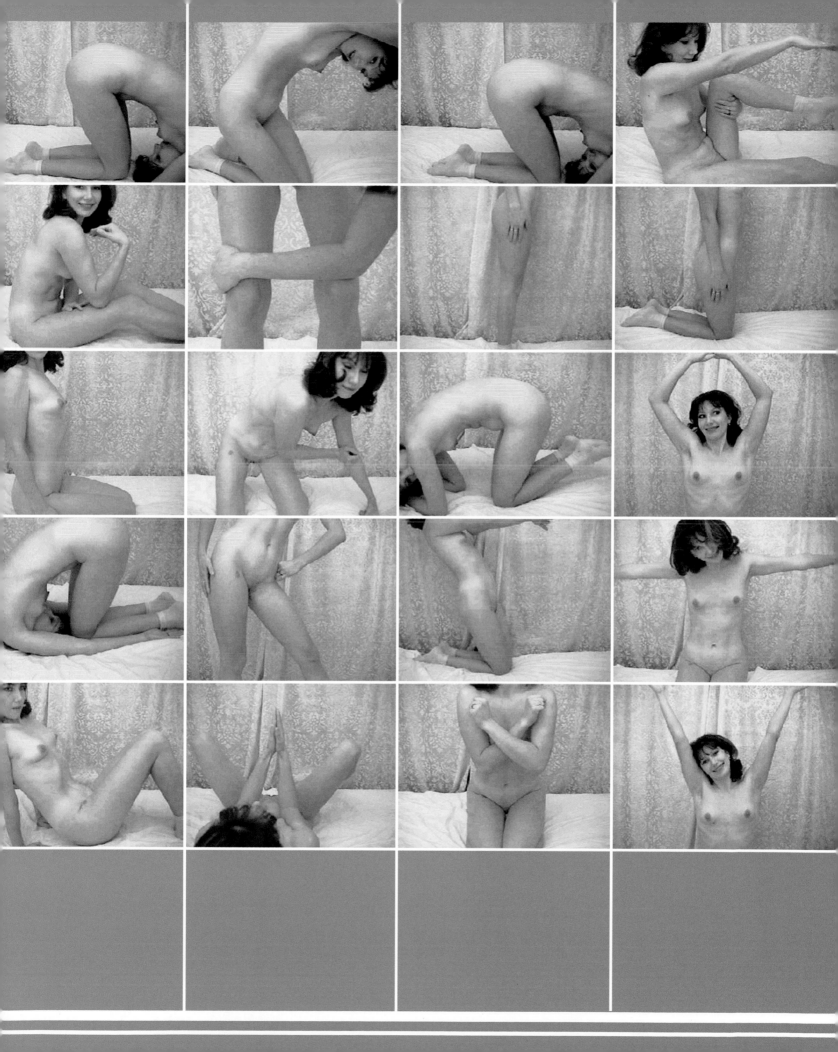

Directory of Design Firms

AdamsMorioka LLC
370 S. Doheny Dr., No. 201
Beverly Hills, CA 90211
310-246-5758
(F) 310-246-0155
Email: sean@adamsmorioka.com
www.adamsmorioka.com
Creative directors/designers: Sean Adams,
Noreen Morioka.

Charles Andres
37 Westcott Rd.
Harvard, MA 01451
978-456-4174
(F) 781-442-1520
Email: charles.andres@east.sun.com
www.E-PIX.com
Creative director/illustrator: Charles Andres.

Billionaires for Bush or Gore
3 Washington Square Village, Apt. 14-H
New York, NY 10012
212-353-9236
Email: andrew@wanderbody.com
www.billionairesforbushorgore.com
Photography: Impact Visuals.

Victor Cheung
IdN Magazine
Shop C, 5-9 Gresson St.
Wanchai
HONG KONG
852-2528-5744
(F) 852-2529-1296
Email: victor@idnworld.com
www.idnworld.com
Creative director/designer: Victor Cheung.

Alan Chan Design Co.
2/F Shiu Lam Bldg., 23 Luard Road
Wanchai
HONG KONG
852-2527-8228
(F) 852-2865-6170
Email: acdesign@netvigator.com
Creative director/designer: Alan Chan.

Citrus
49 Cromwell Rd., Great Glen
Leicester, LE8 9GU
UK
44-(0)870-124-8787
(F) 44-(0)870-124-8742
Email: us@citrus.co.uk
www.citrus.co.uk
Creative directors/designers: Steve Meades,
Jim Cooper.

Scott Clum
Ride Studio
331 Bush St. SE
Salem, OR 97302
(P/F) 503-375-9019
Email: scott@scottclum.com
Creative director/designer: Scott Clum.
Studio manager: Randy Perry. Flash
Engineer: Adam Royer.

C.O.R.E
1136 Washington Ave., 8th Fl.
St. Louis, MO 63101
314-241-2294
(F) 314-241-2770
Email: etilford@core11.com

Faith
26 Ann St.
Mississauga, ON L5G 3G1
CANADA
905-891-7410
(F) 905-891-8937
Email: paul@faith.ca
Creative director/digital illustrator: Paul Sych.

52mm
12 John St., 10th Fl.
New York, NY 10038
(P/F) 212-766-8035
Email: typediva@52mm.com
www.52mm.com
Creative directors/designers: Marilyn Devedjiev,
Damion Clayton.

Gable Design Group
557 Roy St., Ste. 190
Seattle, WA 98109
206-281-7676
(F) 206-281-7333
Email: tonyg@gabledesign.com
www.gabledesign.com
Art director: Tony Gable. Designers: Tony Gable,
Damon Nakagawa. Illustrator: Damon Nakagawa.
Photographers: Tony Gable, Chris Bennion.

John C. Jay
Wieden Kennedy Tokyo/Studio Jay
(Portland, OR)
Infini Bldg. B1
8-7-15 Akasaka Minato-ku
Tokyo
JAPAN 107-0052
Email: johnj@wk.com
Creative director: John Jay. Art director: Philip
Lord. Designers: John Jay,
Joshua Berger (Plazm), Koichi Inoue.
Illustrator: Katsura Moshino. Copywriters:
Jimmy Smith, Barton Corley. Rappers: Zeebra,
Twigy, Dev Large. Animation: Taku Inoue, Imai
Toons, Hiroyuki Nakao, Shin Nakagome, Cavier.
Photographers: John Huet, Christian Witkin.

Haley Johnson Design Co.
3107 E. 42nd St.
Minneapolis, MN 55406
612-722-8050
(F) 612-722-5989
Creative director/designer: Haley Johnson.
Illustrators: Haley Johnson, David Bowers.

Max Kisman
95 Bolsa Ave.
Mill Valley, CA 94941
415-380-8303
(F) 415-389-6738
Email: maxk@maxkisman.com
Designer/illustrator: Max Kisman.

Marketing Associates USA
701 N. Westshore Blvd.
Tampa, FL 83609
813-636-3333
(F) 813-636-8943
Email: mpetty@maiusa.com
Art director/designer: Michael Petty.
Photo illustrator: Graham French (Masterfile).

Steven McCarthy Design
1985 Selby Avenue
St. Paul, MN 55104
(P/F) 651-917-7551
Email: seminal@earthlink.net
www.home.earthlink.net/~seminal
Creative director/designer: Steven McCarthy.

Modern Dog
7903 Greenwood Ave. N.
Seattle, WA 98103
206-789-7667
(F) 206-789-3171
Email: bubbles@moderndog.com
www.moderndog.com
Designers/illustrators: Robynne Raye, Michael
Strassburger, Vittorio Costarella.

Oh Boy! A Design Company
49 Geary St., Ste. 530
San Francisco, CA 94108
415-834-9063
(F) 415-834-9396
Email: dboland@ohboyco.com
Art director: David Salanitro. Designers:
David Salanitro, Ted Bluey, Ryan Mahar.
Photographers: Randy Yau, Hunter L. Wimmer.
Copywriters: Ted Bluey, Ryan Mahar.

Rafal Olbinski
142 E. 35th St.
New York, NY 10016
212-532-4328
(F) 212-532-4348
Creative director/designer/illustrator:
Rafal Olbinski.

Pentagram London
11 Needham Rd.
London W11 2RP
UK
44-(0)20-7229-3477
(F) 44-(0)20-7727-9932
Email: email@pentagram.co.uk
www.pentagram.com
Creative director/designer: Angus Hyland.

Planet Propaganda
605 Williamson St.
Madison, WI 53703
608-256-0000
(F) 608-256-1975
www.planetpropaganda.com
Creative directors: Dana Lytle, Kevin Wade,
John Besmer. Designers: Kevin Wade, Dan
Ibarra, Darci Bechen, Lin Wilson, Michael
Byzewski, Martha Graettinger, Brad DeMarea.
Copywriters: John Besmer, Seth Gordon, Dan
Ibarra, James Breen. Illustrators: Kevin Wade,
Lin Wilson, Martha Graettinger. Photographers:

Steve Eliason, Mark Salisbury.
Plazm
P.O. Box 2863
Portland, OR 97208-2863
503-528-8000
(F) 503-528-8092
Email: josh@plazm.com
Art directors: Joshua Berger, Niko Courtelis,
Pete McCracken, Enrique Mosqueda. Designers:
Niko Courtelis, Enrique Mosqueda, Joshua
Berger, Andre Thijssen, John Kieselhorst, Linda
Reynen, Dylan Nelson, Jon Steinhorst.
Illustrators: John McKenzie, Linda Reynen,
Simona Bortis. Photographers: Shirin Neshat,
Dan Forbes, Christian Witkin, Lars Topelman.

Pushpin Group Inc.
18 E. 16th St.
New York, NY 10003
212-255-6456
(F) 212-727-2150
Email: seymour_chwast@pushpininc.com
Designer/illustrator: Seymour Chwast. Editor:
D.K. Holland.

Pyro Brand Development
8750 North Central Expressway
Dallas, TX 75231
214-891-7600
(F) 214-891-5868
www.branddevelopment.com

Yvo de Ruiter
Studio Dumbar
585 EV Den Haag
THE NETHERLANDS
070-416-7416
(F) 070-416-7417
Email: yvo@dumbar.nl
Art director/designer/illustrator: Yvo de Ruiter.

Sagmeister Inc.
222 W. 14th St.
New York, NY 10011
212-647-1789
(F) 212-647-1788
Creative director: Stefan Sagmeister.
Designers: Stefan Sagmeister, Hjalti Karlsson.
Photographers: Tom Schierlitz, Lou Reed.
Illustrators: Martin Woodtli, Kevin Murphy.

Mike Salisbury, LLC
25 18th Ave.
Venice, CA 90291
310-392-8779
(F) 310-392-9488
Email: mikesalcom@aol.com
www.mikesalisbury.com
Creative director/designer: Mike Salisbury,
Terry Abrahamson. Editor: Kate Noel-Paton.
Ad copy: Tor Naerheim, Sjornd Leifting,
Anja Duering, Tony Davis, Jim Wojpowicz,
Allana Lee.

Segura Inc.
1110 N. Milwaukee Ave.
Chicago, IL 60622
773-862-5667
Email: sun@segura-inc.com
Creative director/designer: Carlos Segura.

Stoltze Design
49 Melcher St., 4th Fl.
Boston, MA 02210
617-350-7109
(F) 617-482-1171
Art director: Clifford Stoltze. Designers: Clifford
Stoltze, Wing Ip Ngan, Cynthia Patten, Tammy
Dotson, Violet Shuraka, Brian Azer. Illustrators:
Cynthia von Buhler, Wing Ip Ngan, various
("Anon" poster).

titanium
126 Main St.
Northampton, MA 01060
413-586-4304
(F) 413-585-0577
Email: holly@element22.com
Creative directors: Mitch Anthony, Dann De
Witt, Baysie Wightman, Devein Grady. Art
directors: Dann De Witt, Frank Ford, Holly Kesin.
Designers: Dann De Witt, Scott Dunlap,
Demelza Rafferty, Frank Ford, Holly Kesin.
Copywriters: Dann De Witt, Scott Dunlap.
Photographers: Softimage–James Wojcik
(courtesy Blind Spot Artist Representation,
New York).

Turkel Schwartz & Partners
2871 Oak Ave.
Coconut Grove, FL 33133-5207
305-445-9111
(F) 305-448-6691
Email: info@tspmiami.com
www.tspmiami.com
Executive creative director: Bruce Turkel.
Creative director: Kirk Kaplan. Art directors:
Bruce Turkel, David Garcia. Illustrator: Dan
Gonzalez. Copywriters: Mike Calienes, Ian
Mavorah, Bruce Turkel.

Rick Valicenti
Thirst
132 W. Station St.
Barrington, IL 60010
847-842-0222
(F) 847-842-0220
Email: rick@3st2.com
Director/writer: Rick Valicenti.
Animator: Gregg Brokaw.

James Victore Inc.
47 South Ave.
Beacon, NY 12508
845-831-9375
(F) 845-831-9370
Email: victore@interport.net
Designer/illustrator: James Victore.

Wang Xu & Associates Ltd.
Rm 2104-2105 Youya Pavillion, TianYu Garden
No. 158, Linhezhong Rd.
Guangzhou
PRC
8620-88840548
(F) 8620-38840350
Email: xu@wangxu.com.cn
Creative director/designer: Wang Xu.

Waters Design
22 Cortlandt St.
New York, NY 10007
212-720-0700
(F) 212-720-0777
Email: john@watersdesign.com
www.watersdesign.com
Creative directors: John Waters, Cheryl
Oppenheim. Designers: Yosh Oshima,
Colleen Syron, Michelle Novak, Soo Jin Yum,
Kim Niece. Illustrators: Inat Pelard. Producers:
Jeanne Paguaga, Crystal Harris. Programmers:
Carol Eng, Kason Crowl, Dominic Poon.

Why Not Associates
Studio 17
10-11 Archer St.
London W1D 7AZ
UK
44-(0)20-7494-0762
(F) 44-(0)20-7494-0764
Creative directors/designers: Why Not
Associates. Photographers: Rocco Redondo
(Photodisc); Powerstock Zefa; Mark Molloy.

Stewart A. Williams Design
1919 E. Thomas St.
Seattle, WA 98112
206-322-5740
(F) 206-467-4337
Email: april2393@aol.com
www.sawdesign.com
Creative director/designer: Stewart Williams.
Illustrators: Mark Jaquelle, Pat Moriarity.
Photography: Curt Doughty.

Peter Yates
ESPN Magazine
New York, NY
212-515-1068
Email: peter.yates@espnmag.com
Design director: Peter Yates. Designers: Peter
Yates, Yvette Francis, Henry Lee (The BRM).
Photo illustrators: Nitin Vadukul, Amy Guip.
Photographers: Drew Endicott, Isabel Snyder,
Amy Guip, Scott Schafer, Nick Cardillicchio.
Editors: Stephen Rodrick, Shelly Youngblut,
Jeff Bradley. Prop stylist: Tilna Attila,
Kaboom! Design.

ABOUT THE AUTHOR

Laurel Harper is a writer and author specializing in design topics. A former editor of *HOW* magazine, she now contributes regularly to *Idn* and *Fliq* magazines, published in Asia, as well as *Step by Step Graphics*, *Communication Arts*, *Graphis* and *HOW*. Her last book was *Radical Graphics/Graphic Radicals* (Chronicle Books). She lives in Bedford, Kentucky.